BOSCH

T0383831

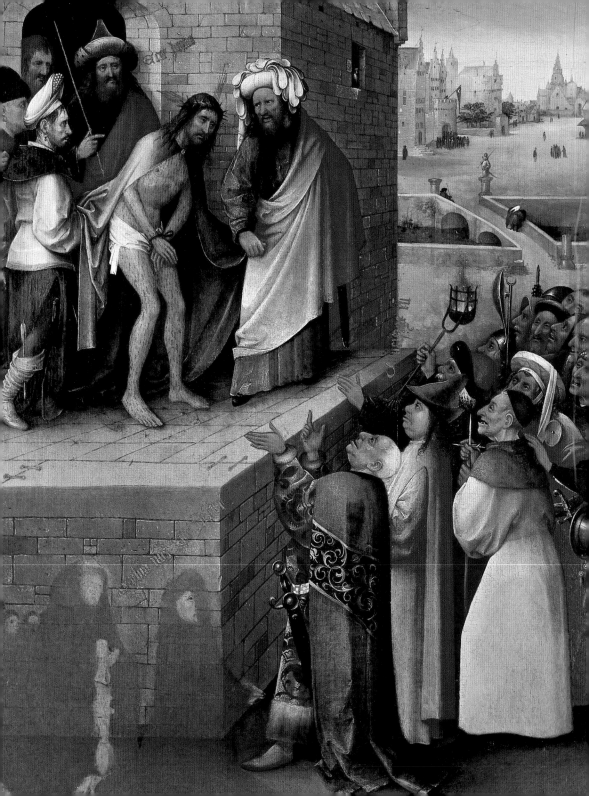

MASTERS OF ART

BOSCH

Brad Finger

PRESTEL
Munich · London · New York

Front Cover: The Haywain (detail), c.1500–1516

© Prestel Verlag, Munich · London · New York 2020
A member of Verlagsgruppe Random House GmbH
Neumarkter Strasse 28 · 81673 Munich

In respect to links in the book, Verlagsgruppe Random House
expressly notes that no illegal content was discernible on the linked
sites at the time the links were created. The Publisher has no influence
at all over the current and future design, content or authorship of the
linked sites. For this reason Verlagsgruppe Random House expressly
disassociates itself from all content on linked sites that has been
altered since the link was created and assumes no liability for such
content.

Prestel Publishing Ltd. Prestel Publishing
14–17 Wells Street 900 Broadway, Suite 603
London W1T 3PD New York, NY 10003

A CIP catalogue record for this book is available
from the British Library.

Editorial direction Prestel: Constanze Holler, Stella Christiansen
Copyediting: Jane Michael
Production management: Andrea Cobré
Design: Florian Frohnholzer, Sofarobotnik
Typesetting: ew print & medien service gmbh
Separations: Reproline mediateam
Printing and binding: Litotipografia Alcione, Lavis
Typeface: Cera Pro
Paper: 150g Profisilk

MIX
Paper from
responsible sources
FSC® C021956

Verlagsgruppe Random House FSC® N001967

Printed in Italy

ISBN 978-3-7913-8625-6

www.prestel.com

CONTENTS

6 Introduction

8 Life

38 Works

110 Further Reading

INTRODUCTION

Hieronymus Bosch remains an enigma, an artist full of contradictions. His visions of "the deepest bowels of hell" are among the most recognisable pictures in art history. They had the power to captivate audiences in his own time, and they still fascinate us today. Bosch the man, however, is largely a mystery. There are remarkably few surviving details of his life, fewer than for many other artists of his time. What were the dates of his birth and marriage? Exactly where and when did he produce his masterworks? Did he travel outside his home city? How did he die? None of these questions can be definitively answered today, despite the best efforts of modern research.

What we do know about Bosch's life indicates that he was a rather conservative, ambitious member of a small but busy provincial city. He married into a family above his own class, and he used this marriage—along with his growing fame as an artist—to become part of the city's social elite. Bosch's paintings, however, were radically inventive and, at times, almost shockingly vivid. His fantastical landscapes can be charged with eroticism, terror and mystery. The nudes in his *The Garden of Earthly Delights* interact with the natural world in ways that strongly suggest the sex act. Other images, such as *The Temptation of Saint Anthony*, feature hideous demons—part human, part animal and part machine—that mutilate and destroy human sinners with gleeful abandon. In some ways, Bosch was part of a larger revolutionary trend in fifteenth-century culture. His immediate predecessors, including Jan van Eyck, had introduced a new and striking realism to their depictions of people, nature and Bible stories. However, their art often looks staid and conventional when compared with Bosch's theatrical work. To modern eyes, in fact, some of Bosch's pictures can seem out of place in a gallery of Old Masters. How could these images have been acceptable in a conservative, late-medieval world? How much do we know about the way people of Bosch's time perceived his art?

Hieronymus Bosch appears to have been an exceedingly popular artist in his own lifetime, and that popularity remained strong for about a hundred years after his death. His art was copied extensively throughout Flanders in the fifteenth century, and Bosch originals made their way into the collections of Henry III of Nassau; Philip the Fair, Duke of Burgundy; and, eventually, King Philip II of Spain. Philip II developed a special liking for Bosch's work, and his collection formed the basis of what is now the most important group of Bosch paintings in Madrid's Prado museum. This

connection is remarkable because Philip was the most ascetic of monarchs, adhering to an unusually strict practice of Catholicism. His grand estate, the Escorial, was known for its spare use of decoration and its austere façade and interiors; and he himself had a preference for severe, black attire. How did such a monarch become attached to an artist of vivid colours and intensely sensual, almost lurid, images?

All of these questions are difficult to answer today, as the details of Bosch's life have been lost and interest in his work was largely extinguished for more than 200 years. Only in the late nineteenth century did scholars begin to resurrect Bosch as a painter worthy of study. As it had during his lifetime, Bosch's fame rose quickly, and by the early 1900s his art had become fashionable again. Surrealist artists of the 1920s, including André Breton and Salvador Dalí, were inspired by Bosch; and art critics saw his method of transforming and reconfiguring everyday objects and characters as proto-Surrealist. However, it was not until the 1930s and 1940s that academics began to explore what Bosch's art actually meant for the people of his age. Their studies explored the sources of his art, from Biblical passages to poems and manuscript illuminations. Results of this work revealed an artist who may not have been a provocative rebel. Instead, his work may have reflected his own conservative lifestyle—and his era's Catholic traditions—more closely than once thought.

Beginning in the late twentieth century, scholars have brought infrared imaging and other analytical techniques to the study of Bosch. Their efforts have revealed new information about how the artist made his paintings; and they have helped to clarify, to an extent, which of his surviving works are by his hand and which are by assistants or followers. Yet, despite all these investigations, Bosch remains almost as much a mystery today as he was over the past 500 years. It is this mystery, in part, that makes his work endlessly seductive and influential.

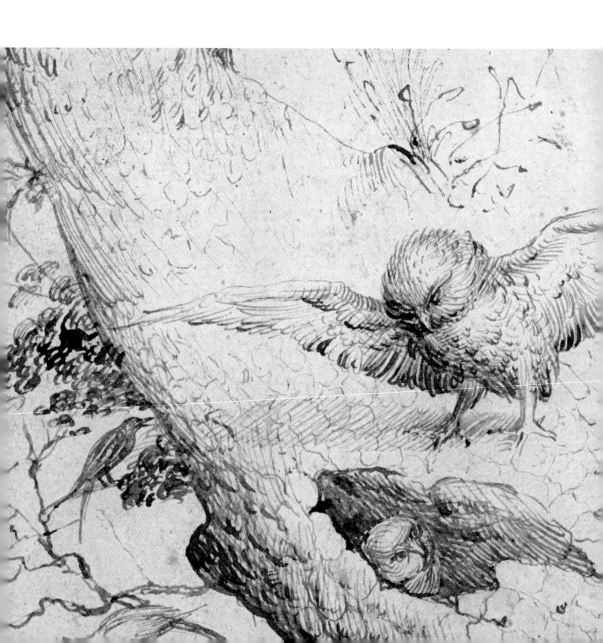

LIFE

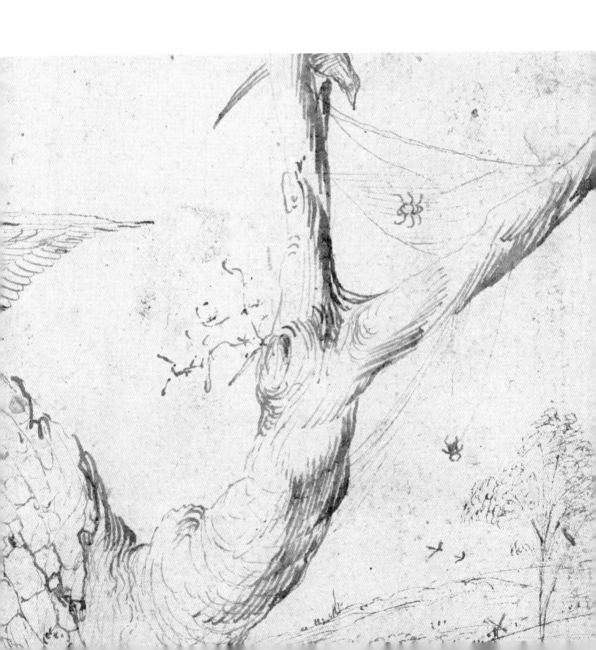

WHAT DO WE KNOW ABOUT BOSCH'S LIFE?

The mysterious art of Hieronymus Bosch has long inspired an interest in the painter's own life. Yet, as early as 1604, the Flemish biographer and art historian Karel van Mander found that Bosch's personal history was almost completely lost. This lack of evidence remains a problem for historians today. Much of what we know about Bosch comes from tax documents, a brief obituary and a few recorded transactions between Bosch and his clients. None of these documents sheds light on Bosch's character, and they provide a frustratingly incomplete outline of his life story.

Bosch came from a family of painters who had moved to s'Hertogenbosch from Nijmegen, a Dutch city near the German border. Their surname, van Aken, indicates family origins in the German cathedral city of Aachen, about 93 miles (150 kilometres) south of Nijmegen. Hieronymus' grandfather, Jan van Aken (c.1380–1454), is the first member of the family to be recorded as living in s'Hertogenbosch, possibly as early as 1430. Jan and his painter sons, Thomas (c.1407–1462), Goswin (c.1418–1467), Jan (c.1413–c.1471) and Anthonius (Bosch's father, c.1420–1478), worked primarily for the Brotherhood of Our Lady, a leading confraternity (religious community) in s'Hertogenbosch. The Brotherhood was more than a century old at that time and had been founded to worship the Virgin Mary. Specifically, this worship centred on a wooden statue of the Virgin known as "Onze Lieve Vrouw" ("Our Lady"), which was believed to be associated with miracles. The Brotherhood also served as an important economic engine in the town, providing employment for painters and other artisans like the van Aken family. In addition, it offered its members a form of social acceptance, as many prominent individuals in the town were part of its ranks. Records indicate that Jan van Aken was able to join the confraternity in about 1430 as an ordinary member, the less prestigious form of membership available to people of his social class. Jan received a variety of commissions from the Brotherhood, projects that ranged from a canvas depicting Saint Mary of Egypt to more menial tasks: gilding church candelabras and painting the Brotherhood's chapel ceiling.

In 1455, Jan's son Anthonius (who is often referred to as "Anthonius the Painter") also became an ordinary member of the Brotherhood of Our Lady. Seven years later, he acquired a house on the market square of s'Hertogenbosch—on the side of the square reserved for craftsmen and the working class. This house became both his home and workshop. Anthonius and his wife Aleid had three artist sons, of whom Hieronymus was the youngest. There are no precise birth records for any of these children, but scholars estimate that Bosch was born sometime around 1450. His birth name was Jheronimus van Aken. "Jheronimus" is a Dutch variant of the Latin name Hieronymus, or "Jerome" in English. Saint Jerome, an early Christian theologian who translated Biblical texts into Latin, had become a popular figure of devotion in fifteenth-century Europe, and many families named their sons after him.

HIERONYMO BOSCHIO PICTORI.

Quid ſibi vult, Hieronyme Boſchi,
Ille oculus tuus attonitus? quid
Pallor in ore? velut lemures ſi
Spectra Erebi volitantia coram
 Tam potuit bene pingere dextra.

Aſpiceres? Tibi Ditis åuari
Crediderim patuiſſe receſſus
Tartareaſque domos · tua quando
Quicquid habet ſinus imus Auerni

The oldest record of Jheronimus van Aken dates from 1474, when he and his father and brothers were involved in a real-estate transaction. In general, people appeared in such documents only if they signed a deed or played another direct role in the matter—activities that would require them to be adults, or at least 24. Scholars, therefore, believe Bosch may have been about 24 at the time, providing evidence for his birth date of around 1450. The document also indicates that young Jheronimus went by the nickname "Joen."

In 1481, Bosch again appears in the records as a painter and as the husband of Aleid van de Meervenne. The two may have married at this time, though there is no mention of exactly when the marriage took place. Aleid would have an important influence on her husband. Documents show she came from a well-to-do family in s'Hertogenbosch, and she and Joen appear to have moved into a house that she inherited from her grandfather. Named "Inden Salvatoer," it was a much grander building than the Bosch family home, and it stood on the side of the Market Square where many of the town's leading families resided. Aleid would later inherit other real estate, and she and Bosch are listed as paying high levels of city tax, an indication of wealth. Most importantly, Bosch's rising prominence probably helped him advance within the Brotherhood of Our Lady. Joen had become a regular member of the Brotherhood in 1486, but in 1488 he was announced as a "sworn" member, a position of honour normally reserved for the social elite. His ascendancy was confirmed later that year, when he hosted a banquet in his house for the Brotherhood's other sworn members. Guests at the banquet included the future Holy Roman Emperor, Maximilian I. Bosch's rise in social status was unusual in his time, and scholars generally ascribe it to a combination of factors: his advantageous marriage and his growing fame as an artist within s'Hertogenbosch and beyond.

Despite Bosch's prominent position within the town elite, historians are not entirely clear where he established his primary workshop. Records show that he sold his share of his father's house and workshop to his elder brother Goessen. Thus,

he probably set up his own business in his new home with Aleid. Joen's workshop would grow to include several assistants as he acquired more commissions. Yet, as with his personal life, records of these commissions are extremely scant. Documents from the early 1480s suggest Bosch may have worked with his brother Goessen on an altarpiece for the chapel of the Brotherhood of Our Lady. Other recorded projects show his diverse talents, but they are relatively minor in scope. They range from a calligraphy project, in which he added names to a decorative panel that listed all the sworn brothers of the confraternity, to the decoration of sculpted altarpieces and the design of stained glass windows.

Few records describe how Bosch acquired the major altarpiece projects for which he is famous today. The finest documented project came from Philip the Fair, Duke of Burgundy and King of Castile. From 1504 to 1505, Philip stayed at s'Hertogenbosch, where he may well have met the town's most celebrated painter. He also commissioned "Jheronimus van Aken, called Bosch" at this time to paint a large panel of the Last Judgement. Though this particular version of the Last Judgement has not survived, the record of the commission offers important proof of Bosch's fame even among the highest members of European nobility. It also confirms his use of the name "Bosch" as a moniker. Joen may have done this in part as a form of publicity for both himself and his growing home city. Europe in 1500 was becoming more mobile, with both patrons and artists travelling to places where they could purchase or produce art.

Bosch's fame, and his close ties with s'Hertogenbosch, probably meant that most of his patrons brought commissions to him. Records indicate that Bosch travelled little, if at all, during his lifetime.

Bosch probably died in 1516, the year an epidemic that may have been plague or cholera spread through the town and killed many of its citizens. A funeral mass in his honour was held in August of that year at the chapel of the Brotherhood of Our Lady in St. John's church. When documenting this funeral, the Brotherhood recorded an unusual budgetary detail: the amount paid for Bosch's mass was 1 stuiver more than necessary, leaving the Brotherhood with a small financial surplus. Aleid lived for about six more years after her husband's death. She and Joen were childless, though Bosch may have worked with two of his nephews, Jan and Anthonius, who were also artists.

MESSAGES IN BOSCH'S ART

When describing the style of an artist, historians often rely on a general timeline over which that style appears to have evolved. However, none of Bosch's paintings are dated, and scholars still disagree over which of his works are "early" and which are from a more "mature" or "late" period. Other factors have also complicated the development of an artistic timeline. Certain paintings long attributed to Bosch have been found to be inauthentic, as the wood in their panels dates from well after the master's lifetime. Lastly, most experts tend to believe Bosch reached artistic

maturity fairly early in his career. Only one or two of his surviving works suggest the hand of a younger, developing artist.

Because of such limitations, an analysis of Bosch's art should rely less on dating and more on the content of the paintings themselves. Bosch's images are among the most complex of his day. They range from the raucous energy of *The Temptation of Saint Anthony,* with its blazing hell fires and mutant devils swirling around the canvas, to the eerily calm *Adoration of the Magi*, with its vast, foreboding landscape, and the orgasmic, sensual details in *The Garden of Earthly Delights*. Bosch also worked on a variety of subjects. He painted saints, Biblical events and a range of allegorical works that focused on Christian teachings and values. Despite its variety, however, Bosch's art repeatedly reveals certain themes.

As scholars have noted, Bosch was most probably influenced by certain Catholic philosophies and movements of his day. One such was the "Devotio Moderna" (or "Modern Devotion") movement, which inspired a devotional book called *The Imitation of Christ* (c.1418–1427), by the German-Dutch author Thomas à Kempis. Both the movement and the book became especially popular throughout Netherlandish Europe in the fifteenth century. They urged people to achieve an inner piety, free of sinful thoughts and worldly desires, and to live a simple life. They also promoted the asceticism of Saint Anthony and other "hermit" saints, who withdrew from the world and devoted themselves to meditation and prayer. Thomas à Kempis referred to these virtues when he wrote: "How

strict and self-denying was the life of the Holy Fathers in the desert! How long and grievous the temptations they endured! How often they were assaulted by the Devil! How valiant the battles they fought to overcome their vices!"

Bosch may have had these teachings in mind when creating his paintings of saints, especially *The Temptation of Saint Anthony*. Saint Anthony was a fourth-century Egyptian monk who retreated to the desert to find spiritual clarity. During this period of isolation, he overcame several encounters with the Devil, who tempted him with visions of beautiful women and even accosted him with beast-like demons. For many of Bosch's Devotio Moderna contemporaries, Anthony's triumph over sin was ascribed to his "strict and self-denying" nature. But it was only Bosch who could portray Anthony's virtues so dramatically in paint. In the *Temptation*, Bosch places Anthony not in the arid desert, but in a fantasy world inhabited by part-human/part-machine/part-animal demons. These henchmen of the Devil can swarm through the air like giant insects, slither along the rivers, hatch out of giant fruit and march in hideous armies. Amidst all of this terror, Anthony remains stoic and steadfast, clutching his Bible and offering devotion to God. Even the sight of a nude temptress does not deter Anthony from his Christian duties.

Another recurring theme in Bosch's art is the folly of sin and its manifestation in society. Many Bosch scholars, including Walter Gibson, describe how fifteenth-century Europe began changing its attitudes toward the poor and the outcast. Cities during this time were expanding, especially in

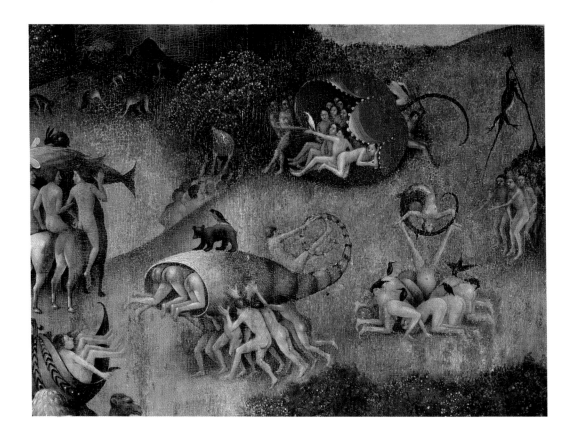

Flanders and the Netherlands, which also led to a growing number of merchants and artisans. People in this social group—sometimes identified as an early-stage bourgeoisie or "middle class"—began adopting values of industriousness and productivity. At the same time, their prejudices against the poor and the socially outcast began to intensify. Such people, who had been tolerated in the Middle Ages as objects of pity, were now condemned as lazy and sinful. Hieronymus Bosch was part of this new urban milieu, and his art reflected its values. Nearly all of Bosch's sinners and devils are based on images of people from the lowest rung of society: beggars, tricksters, usurers, and the lame or handicapped. Very rarely do we encounter members of Bosch's own social class in his art. We can see this link between sin and the outcast individual in a detail from Bosch's *The Last Judgement* (page 15, which includes a drunk man and a washerwoman among the damned. Such imagery may have been inspired, in part, by the riotous Carnival festivals Bosch witnessed every year; festivals that were seen with increasing suspicion by city leaders in s'Hertogenbosch and other urban centres.

The Garden of Earthly Delights, Detail of central panel, c.1495–1505

Bosch's paintings may also reflect a medieval notion that was still prevalent in his day: the "mirror of conscience." Because sin played such a vital role in undermining one's character on Earth, and one's chance for the afterlife, it was necessary to provide visual manifestations (or "mirrors") of that sin in order to help people understand and repent from their evil ways. In art, mirrors could range from simple images of folly and disorder, like Bosch's *Ship of Fools*, to more sophisticated allegories, like *The Garden of Earthly Delights*. Contemporary research into this latter painting suggests that Bosch's "garden", which appears in the central panel, may not be the paradise that earlier historians had claimed. There is an overt sensuality in this work, as seen in a detail on the opposite page. Naked bodies, including some with chapped behinds, frolic among ripe, sexually-charged plants and animal parts. Such behaviour was viewed with suspicion in Bosch's era, especially among the elite class for whom the *Garden* was created. Therefore, some scholars interpret this garden as a world of indulgence, a mirror of hedonism that can only lead to the hellish apocalypse in the right panel of Bosch's triptych.

Bosch was obsessed in his work with eschatological themes of death and judgement. Apocalyptic scenes appear not only in *The Garden of Earthly Delights*, but in several other works, including *The Last Judgement* and *The Temptation of Saint Anthony*. These depictions of hell have a surreal energy unique to their creator, with their crazed demons, scenes of torture and mutilation, and silhouettes of ruined buildings set against a fiery night sky. Similar themes also appear in the work of Bosch's predecessors and contemporaries, but the master of s'Hertogenbosch was unusual in the way he depicted them. Most artists, such as Rogier van der Weyden, devote only a minor portion of their panels to the fall of the damned. Most also show a relatively equal number of damned souls and saved souls. Bosch may have been the first painter to make damnation a leading element in his work. In Bosch's world, most sinners are doomed to Hell; only a select few make it into Paradise. Early Bosch scholars sometimes attributed this quality in his art to a sadistic streak in the painter's character. Modern academics, however, believe Bosch used his hellscapes for a more constructive purpose: to make his viewers understand the urgency of absolving themselves of sin and living a more godly life.

BOSCH'S WORKING METHOD: A BRILLIANT TECHNIQUE

As we have already seen, fifteenth-century art in northern Europe had undergone a transformation before Bosch was born. Painters such as Jan van Eyck revolted against the stylised, two-dimensional imagery of the Gothic age. Their Northern Renaissance images reproduced the human and natural world with unprecedented realism and clarity. Van Eyck's generation also developed a painstaking method for achieving this realism. Layer upon layer of slow-drying oil paint was applied to the canvas in order to build up and refine

Rogier van der Weyden, *The Beaune Altarpiece*, c.1450

the images' minutely-rendered details. The result-
ing artwork could achieve a glowing, perfectionist
quality. But this method also had its drawbacks.
Its time-consuming nature limited a workshop's
output, and it also restricted an artist's ability to
revise and re-imagine a work during the painting
process.

Hieronymus Bosch, on the other hand, adopted
a technique that gave him creative flexibility. Like
other panel painters of his day, his workshop be-
gan the artistic process by laying a light-coloured
"ground" layer of chalk on the wooden panel. Bosch
would then use a dark, carbon-based material to
make the underdrawing on which the painted im-
age was based. Bosch was a superb draughtsman,
and modern infrared imaging—which can reveal
the original carbon underdrawings below the sur-
faces of Bosch originals—has shown that the mas-
ter often altered his underdrawing as he painted.
Most of these changes are small, but many involve
significant adjustments to the narrative of the fi-
nal image. Recent studies by the Bosch Research
and Conservation Project, a project dedicated
to studying and preserving the artist's surviving

works, found a striking change in Bosch's *Death
and the Miser* (page 73)—which depicts a greedy
man on his deathbed and the forces working for his
damnation or salvation. In the final painting, Bosch
shows the miser with closed mouth gesturing to-
wards a bag, which represents worldly wealth and
is being held by an amphibian-like creature. The
underdrawing, however, shows the man clasping
the bag in one hand and a lamp in another. Both he
and the demon have open mouths, and are pos-
sibly in the act of "bartering." Bosch's changes
have made the miser somewhat less avaricious,
and the overall image more nuanced in its charac-
ter and meaning.

Another hallmark of Bosch's experimental nature
was the way he applied paint. Eschewing the
thick layers of oil paint typical in fifteenth-century
Flemish art, Bosch applied thinner paint layers
that dried more quickly, enabling him to work at
a faster pace. He also applied fewer layers, and he
often left details in the underdrawing exposed in
the final artwork, making them a part of the visi-
ble composition. Art historians have long noticed
this aspect of Bosch's technique; author Karel van

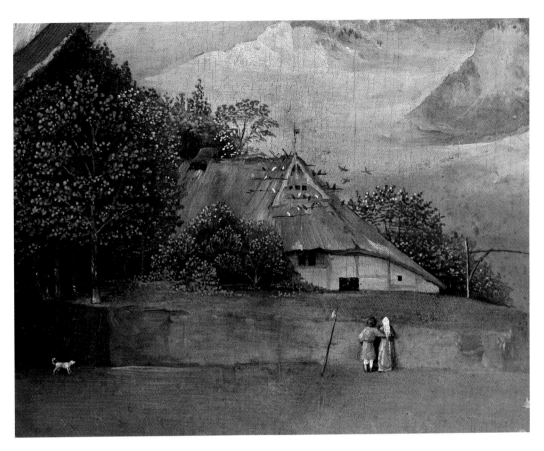

The Adoration of the Magi, Detail of central panel, c.1490–1500

Mander mentioned it as early as 1604. In addition, Bosch would alter and work his paint layer in several ways. He added highlights to show the play of sunlight on the surfaces of objects, and he used a variety of brushwork that ranged from thin to thicker impasto strokes. Bosch even employed the opposite end of his paintbrush to work his surfaces. This variety of applied paint could capture subtle details, help define individual elements of the composition, and provide a sense of energy and movement to the overall work.

Bosch's painted figures do not display the rounded, sculptural quality of Renaissance Italian art, which was being produced at the same time, but they do reveal his exceptional powers of observation and detail. In *The Adoration of the Magi*, often considered one of his later works, Bosch depicts the black Magus's African features with great subtlety and precision (page 20). He also captures the sunlit folds in his robe, as well as the fine details on the decorated white pix in his hand, which contains a gift of incense for the Christ child. This

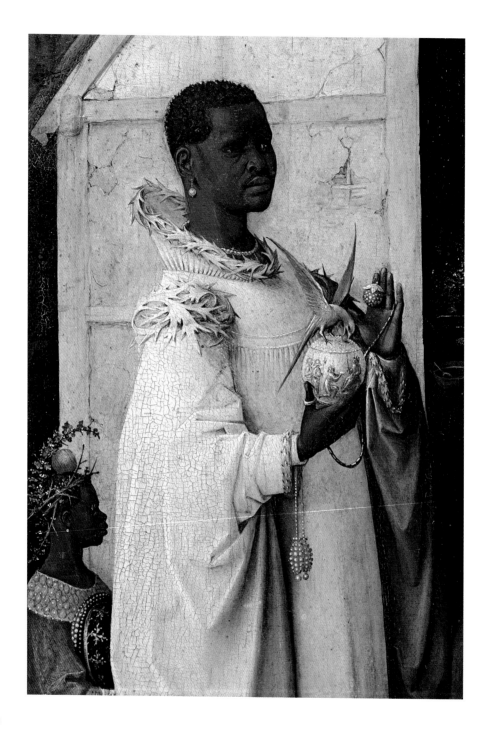

The Adoration of the Magi, Detail of central panel, c.1490–1500

naturalism is blended with Bosch's characteristic flights of fancy, as can be seen in the oversized decorative bird on top of the pix and the cloth foliage that seems to sprout from the Magus's sleeve and collar.

Bosch had a great fascination for nature. His landscapes often play a leading role in his art, and he sometimes imbues them with a life and energy of their own. Bosch's grandest landscape, in *The Adoration of the Magi,* extends across all three panels of the triptych, something like Rogier van der Weyden's landscape in the *Beaune Altarpiece* (page 18). As with the earlier work, the *Adoration* employs aerial perspective, or the use of sharp foregrounds and hazy backgrounds to give a sense of space. Bosch's countryside not only dominates the Nativity scene in the central panel; it also casts an aura of mystery over the entire image. Bosch achieves this, in part, by mixing elements familiar to his viewers, such as the Dutch-style stable, with the fanciful, "oriental" architecture in the far distance and the foreboding mounted armies approaching each other by the river.

We can examine Bosch's affinity for nature closely in a detail from his *Adoration* on page 19. The thatched cottage, with its half timbering, seems to nestle organically into its small hill. Light glistens off the foliage on the trees, as well as the wings of the birds flocking around the roof. Despite the presence of mountains in the background, this serene vignette captures the essence of the countryside of Brabant.

Bosch's quiet, expansive landscape in the *Adoration* represents one style of composition

in his work. A very different style can be seen in his hellish right panel from *The Garden of Earthly Delights.* Here, Bosch creates an intense feeling of unease in his depiction of space. The landscape, which has relatively little depth, is divided into different layers from top to bottom, giving the dark world an unnatural, claustrophobic quality. Within this world, the real and the imagined seem to compete with each other in jarring fashion. At the top of the panel, Bosch's burning city is rendered with incandescent realism. Through a hazy film of smoke, we can make out the angular black shapes of burnt-out buildings and volcanic eruptions of flame. This massive conflagration is reflected, somewhat opaquely, in the cool, misty surface of the nearby lake. But as our eye moves down the panel, the familiar world is left behind and we become immersed in a riot of surreal imagery. The damned souls in Bosch's Hell are shown undergoing a myriad of fantastical torments. His animal demons and instruments of torture may be based on close observations of nature and everyday objects, but the artist takes these real-world models and transforms them in several ways—making them unusually large or combing two or more of them into one hybrid creature. All of these characters, demons and people alike, seem to be trapped in Bosch's nightmare underworld, with everything overseen by a monstrous "tree man" in the middle of the panel.

Another aspect of Bosch's working method—his signature—may seem trivial at first. But Hieronymus was, along with Jan van Eyck, among

the first northern European painters to sign his artworks. Bosch's signature is often bold, showing a talent for calligraphy that would earn him commissions from the Brotherhood of Our Lady. Though scholars are unclear why Bosch attached his name to so many of his paintings, he may have used his signature as a form of advertising, a proclamation that both he and his town were worthy of attention and patronage. Whatever the real reason may have been, Bosch's practice of signing his works indicates the start of a new era in Western art. Leading painters and sculptors would begin to see their art as a creation of their own genius, and not merely as offerings to the Church or their noble patrons.

BOSCH'S DRAWINGS: THE FIRST DRAUGHTSMAN OF NORTHERN EUROPE

As we have seen, Bosch used his expert draughtsmanship to lay the foundations of his great panel paintings. But he also created an extensive body of independent drawings on paper. By 1500, European artists from Albrecht Dürer to Leonardo da Vinci were producing drawings in greater numbers. Jan van Eyck made exquisitely detailed images in silverpoint for his portraits and religious scenes. Silverpoint involved the use of silver wires to render fine lines and shading. But Bosch's drawings, the largest and most diverse of any early Northern Renaissance artist, employ a different technique and appear to be used for a variety of purposes.

Bosch drew largely with pen and ink. And unlike van Eyck's painstaking silverpoints, Bosch's paper art shows a much freer hand. He employed quick, expressive penstrokes and cross hatchings—strokes that resemble the brushstrokes in his paintings and provide a sense of movement and energy to his images. In his "monster" drawings, as seen on the opposite page, the hybrid creatures seem to crawl, hiss, buzz and gesture as living animals would in nature. While the monster drawings appear to be studies, other Bosch works on paper may have been finished artworks in themselves—making them great rarities in the Renaissance era. Two of Bosch's best paper images feature owls, a favourite motif of the artist. One of them, now called *The Owl's Nest*, shows Bosch the naturalist at his finest. The owl family is depicted with the same naturalistic vitality as his monster drawings, but with a less sinister undertone. Bosch also uses an inventive composition, with the massive tree trunk spreading across the entire page and the lightly-sketched town and hills retreating in the far distance. The second drawing is far more complex. It features a "living," anthropomorphised landscape that illustrates the proverb, *The Wood Has Ears, The Field Has Eyes* (p. 25). Above the main image, a written quote admonishes the "mind that always uses the inventions of others and invents nothing itself." Scholars disagree as to the exact meaning of the piece, but it seems to have been intended as a riddle for the viewer to solve. Owls are often a symbol of menace in Bosch's work, and this particular image may warn against the perils of indiscretion or laziness. It may also refer in some

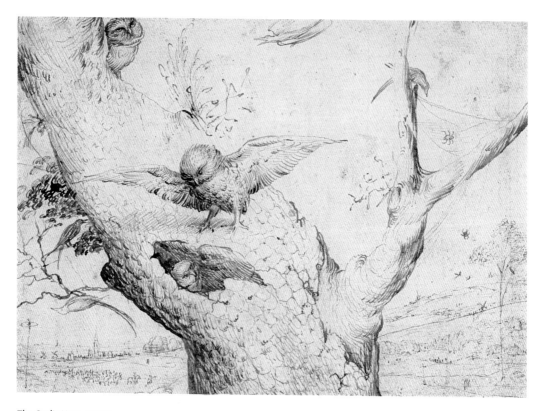

The Owl's Nest, c.1500

way to s'Hertogenbosch itself, as it resembles the city's official seal from Bosch's era: a group of three trees symbolising the "Duke's forest" from which the town originated. But whatever its significance, Bosch's watchful landscape remains a powerful example of his imagination and powers of suggestion.

Another Bosch drawing is directly related to one of his masterpieces. *Tree Man* is probably a variation of the arboreal monster in *The Garden of Earthly Delights*. According to modern scholarship, this work was almost certainly a stand-alone composition, rather than a study for the more famous

painting. Bosch used a variety of pens and penstrokes to create the image, which also features his characteristic owls and a distant cityscape. Unlike the "tree man" from *Garden*, this one seems less like a creature from hell, and more benign towards the tiny humans populating his body. As with *The Wood Has Ears, The Field Has Eyes,* Bosch has composed a riddle for us to solve.

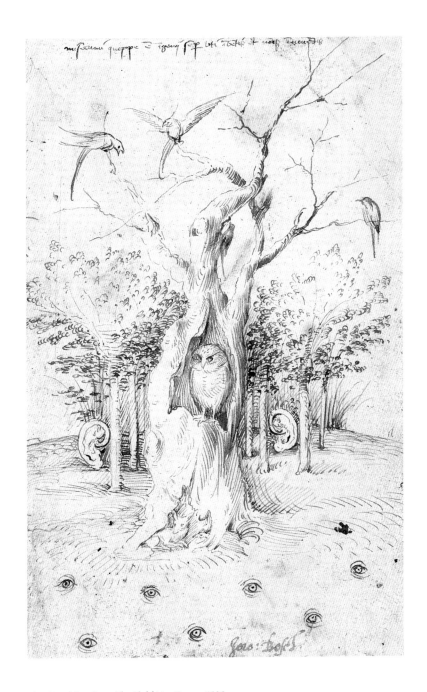

The Wood Has Ears, The Field Has Eyes, c.1500

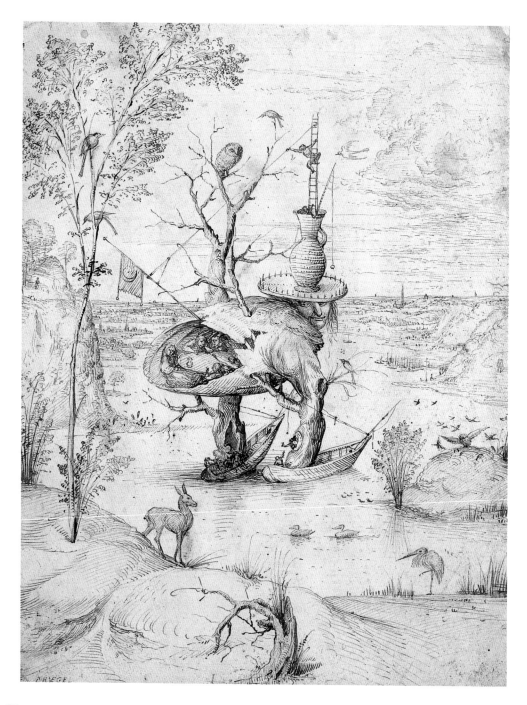

Tree Man, c.1500

BOSCH'S INFLUENCE DURING THE RENAISSANCE

The work of Hieronymus Bosch was recognised and celebrated during his lifetime and for about a hundred years after his death. His "monsters and absurd fantasies" were copied extensively in engravings throughout the sixteenth century. The first known Bosch-inspired engravings were produced in s'Hertogenbosch by Alaert du Hamel, Bosch's contemporary, shortly after 1500. These works were based on images ranging from *The Last Judgement* to *St. Christopher*. Bosch's colourful art had great commercial value, and the sale of Bosch imitations came to be a lucrative business. Hieronymus Cock (1518–1570), an etcher and publisher in Antwerp, was one of the most prominent distributors of high-quality "Bosch-style" prints. He produced his own engravings and also sold Bosch-inspired prints by Pieter van der Heyden (c.1530–1572) and other well-known artists. The Bosch trade became so lucrative, in fact, that the term "Bosch" was often used as a general term for images with fanciful, demonic character.

Not all followers of Bosch, however, were interested purely in commercial success. Pieter Bruegel the Elder (c.1525–1569) began his famous career in the engraving business. One of his first successful prints, *Big Fish Eat Little Fish* (1556), used Bosch's ideas in a far less slavish way. Bosch's influence can be seen in the oversized fish and knife, as well as the hybrid fish-like creatures. But Bruegel adopts these details for a purpose—to visualise a well-known proverb lamenting how the powerful class

in human society tends to prey on the weak. Other Bruegel prints from this era include *Anger* (1558), which comes from a series on the seven deadly sins. Bosch-like details once again appear in abundance, from the fanciful architecture to the varied instruments of torture. But the overall work shows Bruegel's own talent for composition and his ability to illustrate allegories effectively. These talents would earn Bruegel many plaudits. In *Portraits of Some Celebrated Painters of Lower Germany*, from 1572, Domenicus Lampsonius praises Bruegel in verse: "Who is this new Jerome Bosch, reborn to the world, who brings his master's ingenious flights of fancy to life once more so skilfully with brush and style that he even surpasses him?"

Bruegel would soon perfect his own enigmatic style. However, even his mature paintings still contain a hint of Bosch. In his masterpiece, *The Land of Cockayne* (1567), Bruegel subtly ridicules the vices of sloth and gluttony. His depiction of "Cockayne," a land of plenty from medieval folk tales, features three men resting lazily in the foreground, while another man in the background eats his way through a giant cloud of pudding. Despite their luxurious surroundings, the men seem to be trapped in a self-imposed prison and made impotent by their own desires. This sense of foreboding is emphasised, in part, by fanciful details that could have been dreamed up by Bosch, such as the half-hatched chick egg that walks on two legs and has a knife sticking out of its head.

Towards the end of the sixteenth century, many of Bosch's works would end up in the royal collection of King Philip II of Spain (1527–1598). Bosch was

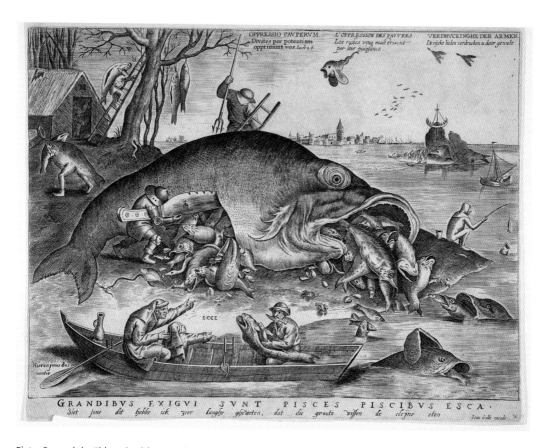

Pieter Bruegel the Elder, *Big Fish Eat Little Fish*, 1556

a favourite artist of the king from his youth. Before ascending to the throne, Prince Philip made two extended visits to Flanders and the Netherlands. During one of these trips, in 1549, he witnessed a religious procession in Brussels that included, in his words, "some devils that looked like paintings by Hieronymus Bosch."

When Philip became King of Spain in 1556, he also inherited s'Hertogenbosch and the Low Countries from his father, the Holy Roman Emperor Charles V (1500–1558). Philip was the most religiously conservative of all Catholic monarchs,

making it his mission to stamp out the scourge of Protestantism in Europe. He was also the head of an empire that had claimed much of the New World for itself. Gold and other precious resources from Spain's colonies had made Philip the richest monarch on Earth; and he used this wealth, in part, to build his massive El Escorial monastery and palace just outside Madrid. Here he would display remarkable works of art, including *The Garden of Earthly Delights*, *The Adoration of the Magi* and other Bosch masterpieces.

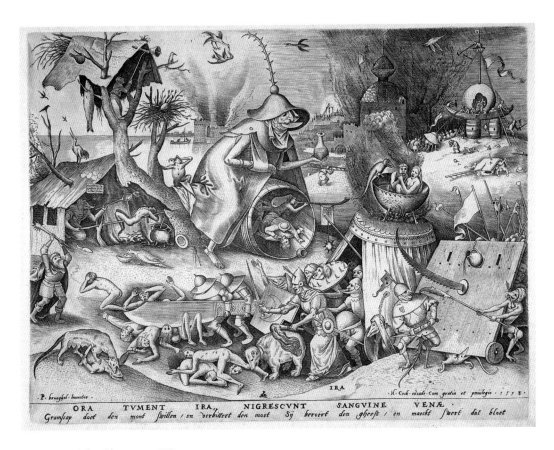

IRA

·P. bruegel·Inuentor· Æ ·H· Cock·excude·Cum gratia et priuilegio· 1 5 5 8 ·

ORA TVMENT IRA, NIGRESCVNT SANGVINE VENÆ.
Gramscap doet den mont swillen / en verbittert den moet Sij beroert den gheest / en maeckt swert dat bloet

Pieter Bruegel the Elder, *Anger*, 1558

Because of the prominence of Bosch's art in Renaissance Spain, Spanish authors were among the first to write extensively about the painter from s'Hertogenbosch. In around 1560, the humanist and art critic Felipe de Guevara, son of a royal minister, discussed Bosch in his *Commentaries on Painting*. In 1605, José de Sigüenza wrote a lengthier treatise on Bosch's art in his *History of the Order of Saint Jerome*. De Sigüenza took pains to explain Philip II's appreciation for Bosch, whose art by that time was being criticised in Catholic Spain as too old-fashioned and possibly heretical.

De Guevara wrote that Bosch should not be maligned this way because the King was a man of "piety and zeal," and if he thought Bosch to be a heretic, "he would never have allowed these paintings in his house, in his monasteries, in his bedchamber, in the chapterhouses and in the sacristy. All these places are adorned with these paintings."

Bosch's popularity in Spain may also have had an effect on one of the country's greatest artists. In 1577, Philip commissioned a major work from the Greek-born Mannerist painter El Greco (1541–1614),

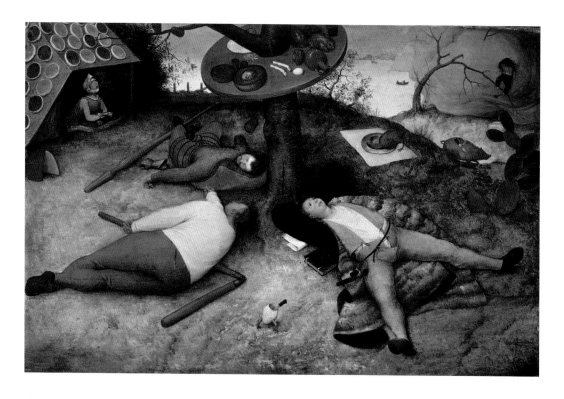

Pieter Bruegel the Elder, *The Land of Cockayne*, 1567

who had just moved from Venice to the nearby Spanish city of Toledo. This work, now known as the *Adoration of the Holy Name of Jesus*, is a monumental representation of the king's piety. Philip appears at the bottom, kneeling in his traditional black cape and black gloves. Along with numerous dignitaries and angels, he is worshipping the holy name of Jesus in the sky above. They may also be celebrating the victory of the Holy League, an alliance of Catholic navies that had defeated the Ottoman Turks in the Battle of Lepanto in 1571. Despite the formal themes of this painting, El Greco's Mannerist style, with its elongated bodies, energetic brushwork and intense colours and expressions, is able to imbue the work with great

drama. He also includes an image of Hell—with its gaping mouth swallowing up sinners—that may pay homage to Hieronymus Bosch.

The end of the sixteenth century also saw an end to Bosch's popularity in Europe. Painters of the seventeenth and eighteenth centuries became less interested in the pre-Reformation Christian themes that preoccupied Bosch. Their clients preferred family portraits or images from classical mythology, and they increasingly saw Bosch's "primitive" devils as medieval and superstitious. Even in Bosch's home town, the memory of its star painter would be diminished in the 1600s when s'Hertogenbosch became a Protestant city under the Dutch Republic. City churches, including St. John's,

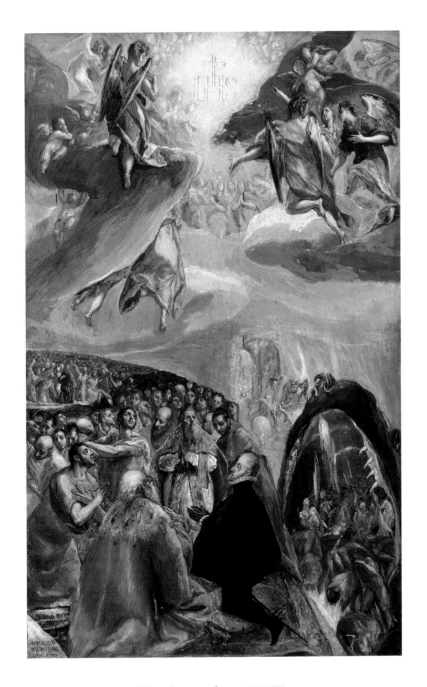

El Greco, The Adoration of the Holy Name of Jesus, 1577–1579

were stripped of their "heretical" Catholic decorations, a process that may have destroyed many Bosch artworks. Over time, the few remaining Bosch originals would survive only in royal or aristocratic collections.

But Bosch's art would never disappear completely from the European imagination. Francisco de Goya (1746–1828) was a court painter to the Spanish crown, and he may well have studied the Bosch masterworks in Philip II's Escorial. Like Bosch, Goya had an interest in human frailty and sin, and he often used intense, monstrous allegorical figures to express this theme. In a late etching entitled *Disparate matrimonial* (Matrimonial Folly), from his series *Los Disparates* (The Follies, 1815–1823), he presents a hideous matrimonial "union" of two writhing bodies fused together in pain. They are surrounded by equally deformed spectators, some of which resemble the animalistic monsters of Hieronymus Bosch. The meaning behind Goya's image, though disputed, is certainly far removed from Bosch and his "Devotio Moderna" ideals. Yet a hint of the older master's world seems to survive in Goya's terrible dreamscape.

BOSCH AND THE MODERN WORLD: REDISCOVERY, FAME AND SCHOLARSHIP

The "rediscovery" of Hieronymus Bosch would begin in the late nineteenth century, an age when art history began to take shape as an academic discipline. Art historians such as Carl Justi (1832–1912) and Hermann Dollmayr (1865–1900) wrote pioneering articles in journals on Bosch. Justi's "The Works of Hieronymus Bosch in Spain" (1889) made an early attempt at organising the master's *oeuvre*. Justi divided the paintings into three categories: (1) religious histories, (2) proverbs and genre paintings and (3) the dreams (which included *The Garden of Earthly Delights* and *The Haywain*). Dollmayr's essay, "Hieronymus Bosch and the Presentation of the Four Last Things in Dutch Painting in the 15th and 16th Centuries," urged art historians to examine the meaning behind Bosch's work—a meaning he believed centred on the "Four Last Things" in Christian theology: Death, Judgement, Heaven and Hell.

This academic interest, however, would soon be overwhelmed by a sudden and unexpected rise in Bosch's popularity within the art world. By the 1920s, modernist art movements were becoming dominant in the West. The classical traditionalists that had once scorned Bosch as old fashioned were now being replaced by Surrealists and abstract artists. Surrealism, in particular, had a great affinity for Bosch—especially the way he could juxtapose the fanciful and the real, the terrible and the beautiful.

Two Surrealist masters who were inspired by Bosch were Max Ernst (1891–1976) and Salvador Dalí (1904–1989). In his groundbreaking work *Celebes* (1921), Ernst concocted a Bosch-like elephant demon, its torso and head made out of a traditional African corn bin, an industrial hose and a modified gas mask. His menacing conglomerate beast, which appears to ogle a headless, statue-like female figure, may suggest the horrors of

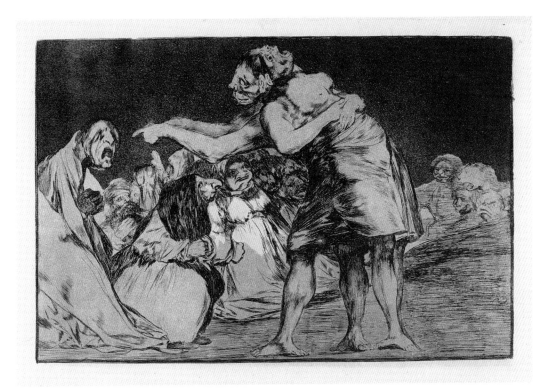

mechanised warfare in World War I (1914–1918). In *The Sublime Moment* (1938), Dalí also lends animation to everyday objects. His image features a broken telephone receiver, a dripping plate of fried eggs and a curious snail. As in Bosch's hells, animal and object are transformed organically. But as with Goya's *Disparates*, the purpose behind Dalí's image is far removed from the moral lessons of Bosch.

Dalí believed in the use of automatism, or subconscious actions, for making art. Artists, he believed, should be sensitive to random moments of inspiration that "reveal" the unseen truth of existence. This method could produce unexpected results that, in Dalí's words, "come nearer to appraising and verifying reality itself... apart from the stereotyped and anti-real image that the intellect has formed artificially." Dalí wanted his art to be suggestive, inviting audiences to probe their subconscious thoughts. Bosch's fanciful imagery had been an inspiration for him, but Dalí admitted that the older artist was mostly reliant on his conscious "imagination"—along with his "religious instinct." Bosch could, like the Surrealists, improvise and change his designs spontaneously. But the older master always had a clear, pre-planned Christian message in mind for all of his work.

Surrealists helped raise the profile of Hieronymus Bosch in both academic and popular culture. For the first time, art historians began to write extensive critiques of Bosch's work. The earliest of these scholars, such as British historian Herbert

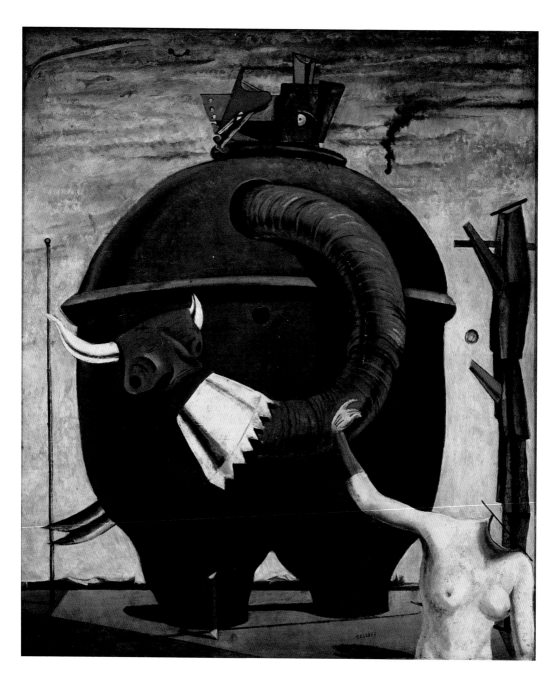

Max Ernst, *Celebes*, 1921

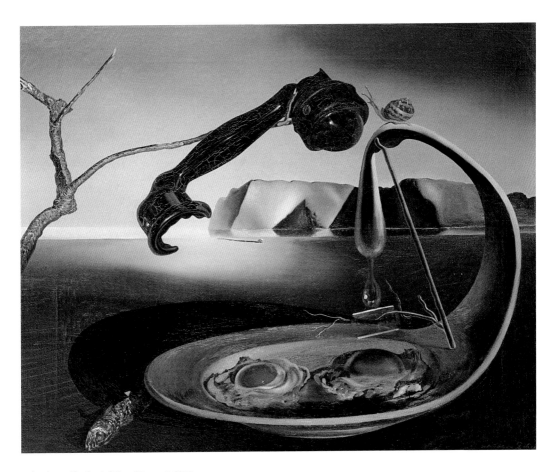

Salvador Dalí, *The Sublime Moment*, 1938

Read (1893–1968), often tried to paint Bosch as a "proto-Surrealist" and a figure who presaged the work of Sigmund Freud. In a 1934 article entitled "Bosch and Dalí," Read argued that Bosch's art broke down the "barriers, both physical and psychological, between the conscious and subconscious mind, ..." Other academics, however, soon rejected Read's ideas. In his pioneering work *Decoding Jeroen Bosch* (1949), Dirk Bax (1906–1976)

argued that the literature, idioms, folk tales and popular allegories of Bosch's day could be used to "decode" the meaning of his images. Bax's efforts led him to write:

"Bosch was not possessed by a deranged spirit but the possessor of a cool, calculating mind. His supreme mastery of the arts is proved by his ability to paint cerebrally constructed devils, of which the component parts each has its own meaning, ...

This, in short, is genius, and modern art historians who see Bosch as a surrealist have been led astray by it. Bosch had a keen eye for the demonic element in what he observed (e.g. in colours and human faces) and he understood and knew exactly how to make use of it and achieve the desired effects."

Bax's work would be followed by that of other scholars, including Walter S. Gibson (1932–2018), who would further clarify Bosch's position within his own society and historical era. Their studies made distinctions between Bosch the painter, who often rebelled against traditional ways of making art, and Bosch the upwardly-mobile citizen of his home city, who shared the conservative values and class prejudices of his peers.

Recently, technological advances have greatly improved our ability to analyse, date and conserve Bosch's few surviving works. One technique, dendrochronology, analyses tree rings from the wood panels that Bosch used for his paintings. Trees develop a new ring annually, and changes in temperature and humidity mean that the rings vary in width from year to year. Patterns made by these rings are distinctive for certain periods in history, enabling dendrochronologists to date the age of the wood in a panel. Once this age is known, researchers then estimate the time a painting might have been executed on the wood. Since it takes several years for harvested wood to be dried and prepared before it can be used by artists, dendrochronology can only offer an age range of about 10 to 20 years for a work of art. Tree ring dating can disprove the authenticity of certain paintings thought to be by Bosch, if the wood is found to date from after Bosch's death. But it cannot provide an exact completion date for a Bosch painting.

Another technological breakthrough, infrared imaging, helps researchers visualise and examine Bosch's underdrawings. Infrared analysis can clarify how Bosch prepared his painting and what changes he might have made during this process. It can also help to assess how much of a work may have been done by Bosch's assistants. In preparation for the 500th anniversary of Bosch's death, which took place in 2016, the Bosch Research and Conservation Project (BRCP) extensively analysed most of the surviving Bosch paintings and drawings from around the world. This effort utilised the latest high-resolution infrared technology. For each artwork they imaged, BRCP researchers took numerous scans of individual details (or "tiles") across a larger painting. The researchers then employed sophisticated digital programs to "stitch" together the multiple tiles to create a seamless, high-resolution infrared picture of the entire work. Such images will help conservators protect Bosch's art for future generations. They will also help scholars learn more about a man who is known almost exclusively through the art he produced. As the project's official statement reads: "We believe that the paintings and drawings Bosch left behind are the most important sources for any historical narrative about this artist."

As the efforts to preserve Bosch's legacy become more sophisticated, popular interest in the artist's work continues to grow. Bosch's influence can now be seen in contemporary art, theatre,

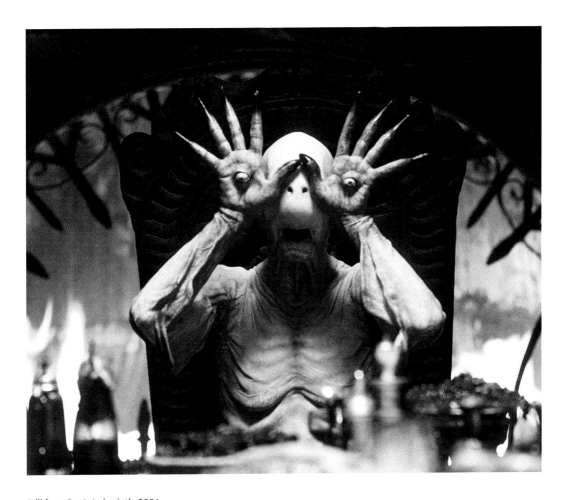

Still from *Pan's Labyrinth*, 2006

advertising and cinema. The 2006 film *Pan's Labyrinth*, by Mexican director Guillermo del Toro (born 1964), stars a girl living in Fascist Spain who tries to escape her oppressive everyday world and enter a fantasy realm populated by whimsical creatures. Set designs and characters in the film have a look inspired, in part, by Bosch's hells. Del Toro's creature Pale Man sits in his fiery realm, his eyes separated from his head and attached to his hands. We can still see in this the eyes of the field from Bosch's great drawing, the eyes that warn us to "do nothing we wish to be secret."

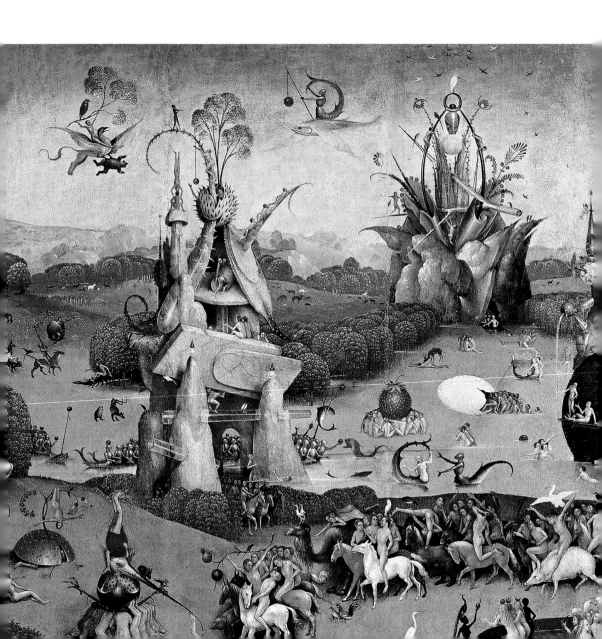

WORKS

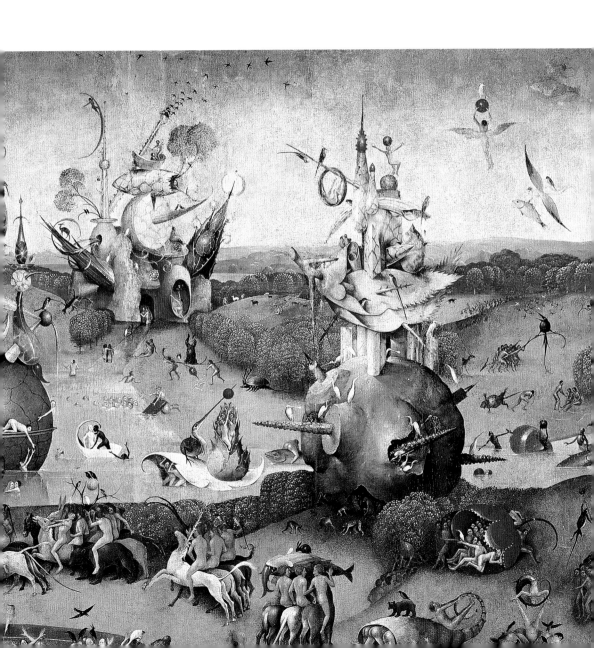

The Garden of Earthly Delights, c.1495–1505

Oil on oak panel
Left panel 187.5 × 76.5 cm, central panel 190 × 175 cm, right panel 187.5 × 76.5 cm
Museo Nacional del Prado, Madrid

"...there are some panels on which bizarre things have been painted. They repre-
sent seas, skies, woods, meadows, and many other things, such as people crawling
out of a shell, others that bring forth birds, men and women, white and black men
doing all sorts of different activities and poses. Birds, animals of all kinds, executed
very naturally, things that are so delightful and fantastic that it is impossible to
describe them properly to those who have not seen them."
(From *The Travel Journal of Antonio de Beatis, 1517–1518*)

As early as 1517, only one year after Hieronymus Bosch's death, the Spanish Cardinal
Luigi d'Aragona was undertaking a journey around Europe, along with his secre-
tary and chaplain, Antonio de Beatis. The latter kept a diary of the trip, in which he
included commentaries of many great artworks seen by the Cardinal's entourage.
When visiting the palace of Count Henry III of Nassau in Brussels, the secretary
described an image of "bizarre" animals and people that he witnessed there. Many
historians consider this document to be the first description of Bosch's most famous
work of art, *The Garden of Earthly Delights*.
The painting was constructed as a triptych, a format typically reserved for churches.
But the work's sensual, often shocking imagery indicates that it was never intended
as an object of worship. Scholars have long argued over the meaning of Bosch's
imagery. Most triptych paintings are meant to be "read" from left to right. In Bosch's
day, the viewer's eye would have focused initially on Adam and Eve in the left panel.
The two are being joined by God, who is represented in the form of Jesus Christ.
Bosch's Garden of Eden is particularly verdant, swarming with exotic animals and
plants, most of which were inspired by early "travelogues": etchings and illuminated
manuscripts from travellers who had been to northern Africa and the Middle East.
This lush world extends into the central panel, which depicts a garden of "delights."
Here, descendants of Adam and Eve, while still unclothed, no longer appear inno-
cent and devoted to God's teachings. Their engagement in erotic pleasures sug-
gests the beginnings of sin and decadence. Oversized figures of owls, a common
theme in Bosch's art, may indicate an ominous future—a future realised in the image
of hell in the right panel. The Fall of Man is now complete, as the once playful ani-
mals and plants have been transformed into demons meting out God's punishment.

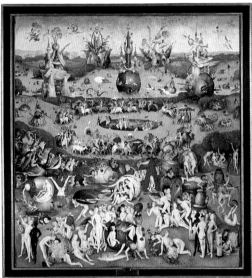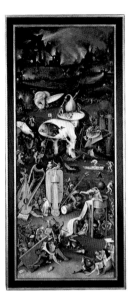

The Garden of Earthly Delights
(detail of left panel), c.1495–1505

Oil on oak panels
Left panel 187.5 × 76.5 cm, central panel 190 × 175 cm, right panel 187.5 × 76.5 cm
Museo Nacional del Prado, Madrid

"And God said, 'Let the earth bring forth living creatures according to their kinds:
cattle and creeping things and beasts of the earth according to their kinds.' And it
was so. And God made the beasts of the earth according to their kinds and the cat-
tle according to their kinds, and everything that creeps upon the ground according
to its kind. And God saw that it was good."
(Genesis 1:24–25)

Hieronymus Bosch devotes the left panel of *The Garden of Earthly Delights* to the
original garden, the Garden of Eden. In 1500, typical paintings of this theme focused
almost entirely on Adam and Eve and the tempting serpent. Bosch follows this trad-
ition to an extent, portraying Adam and Eve in the lower foreground. But his image
inevitably draws the viewer's eye upward, toward the vast landscape that takes up
most of the space. Bosch's Eden is a surreal combination of fantasy and naturalism:
finely detailed animals and trees cluster around fantastical mountains and hills. This
detail features a somewhat garish "fountain of paradise," a uniquely Bosch-style
image that resembles both a work of architecture (somewhat like a Gothic tower)
and an organic creature. The spherical shape at its base could be viewed as a
torso, out of which grow two leafy "arms" and a giant, sprouting head. Spiky leaves
twist and join together to form the eyes and "Cheshire cat" grin of the head, while
other plant and architectural forms burst upward toward the blue hills beyond. The
fountain also includes one of Bosch's signature animals, an owl, which peers out of a
dark hole at the bottom.
Bosch's animals and plants are also a mixture of the natural and the fantastic.
According to many historians, many of these creatures were probably derived from
contemporary illuminated manuscripts and etchings. One widely-distributed book
from the period, the *Journey to Egypt* of fifteenth-century Italian traveler Ciriaco
de' Pizzicoli (also known as Cyriac of Ancona), includes a drawing of a giraffe that
closely resembles Bosch's animal. Other creatures, such as the cattle and birds, may
have been drawn from life; while still others, such as the long-eared, two legged
creature below the giraffe, may have "sprouted" from Bosch's own imagination.

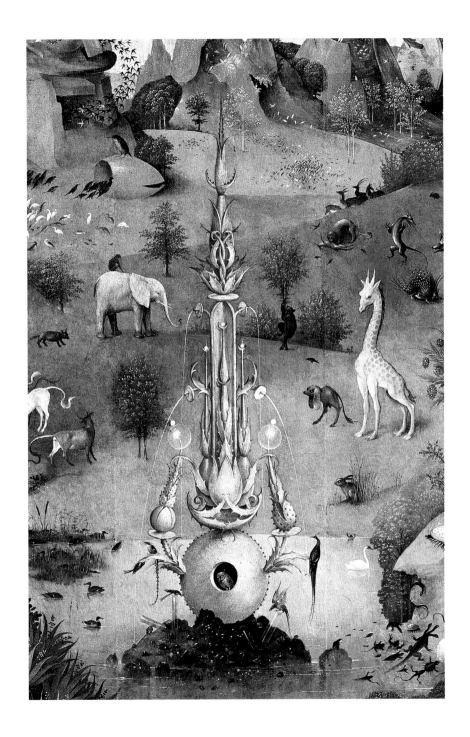

The Garden of Earthly Delights (detail of central panel), c.1495–1505

Oil on oak panels
Left panel 187.5 × 76.5 cm, central panel 190 × 175 cm, right panel 187.5 × 76.5 cm
Museo Nacional del Prado, Madrid

"So God created man in his own image, in the image of God he created them; male and female he created them. And God blessed them; and God said to them, 'Be fruitful and multiply, and fill the earth and subdue it; and have dominion over the fish of the sea and over the birds of the air and over every living thing that moves upon the earth.'"
(Genesis 1: 27–28)

At first glance, the central panel of *The Garden of Earthly Delights* may resemble a continuation of the Eden we have seen in the left panel. Bosch, in fact, extends the same landscape across both sections of the triptych. But as recent scholarship suggests, the artist may have intended this garden of delights as a type of "Grail", or deceptive paradise. Human figures here are portrayed in the same naked state as Adam and Eve, but their nakedness is no longer a sign of innocence. The people have warped God's command to "be fruitful and multiply," using it as an excuse for lustfulness and sin. The oversized animals, painted with such precision that we can often identify individual species, seem to act as willing accomplices in the wild orgy. Fifteenth-century folklore often used birds and fruits as symbols for sexual appetite or sexual deviance. But very rarely in this period do we see the erotic side of human nature captured so boldly and directly. In the detail shown here, the descendants of Adam and Eve are portrayed in ecstasy as they mount deer and birds and devour the nectar of fruit. A couple half-submerged in the dark, fetid water unite in carnal desire, with the male figure aggressively restraining the woman's arm and looking away from her with a lascivious glance. On top of a giant mallard duck, we see the coupling of a light-skinned man and dark-skinned woman, another image meant to express illicit desire. Bosch also includes imagery that alludes directly to sexual reproduction, such as the blue porcupine in the top right corner, which sits within a kind of amniotic sac. All of these details contribute to Bosch's visual representation, or "mirror," of sinful lust, the consequences of which will be visualised even more dramatically in the triptych's right panel.

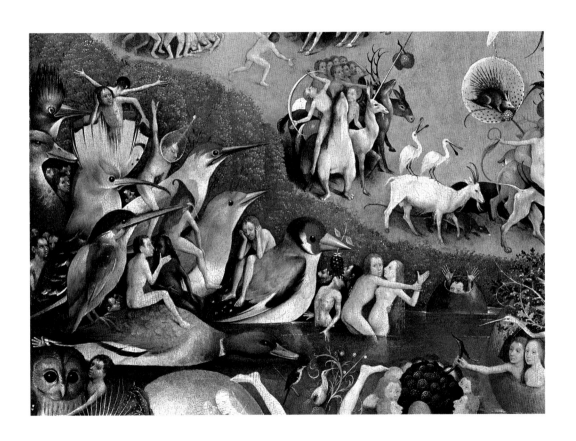

The Garden of Earthly Delights (detail of right panel), c.1495–1505

Oil on oak panels
Left panel 187.5 × 76.5 cm, central panel 190 × 175 cm, right panel 187.5 × 76.5 cm
Museo Nacional del Prado, Madrid

"Then from the smoke came locusts on the earth, and they were given power like the power of scorpions of the earth; ... they were allowed to torture (men) for five months, but not to kill them, and their torture was like the torture of a scorpion when it stings a man. And in those days, men will seek death and will not find it; they will long to die, and death will fly from them."
(Revelation 9: 3–6)

Bosch's naked revellers are now suffering the hellish persecution their sinful life has warranted—a persecution worse than death itself. Once again, the painter shows himself to be a master of vivid drama. The Netherlandish artists who preceded Bosch, including Jan van Eyck and Rogier van der Weyden, often avoided direct images of hell. In his Beaune altarpiece, van der Weyden only reveals hell's fiery entrance, along with a procession of terror-stricken sinners. Bosch, however, was willing to take his viewers all the way down to the underworld, a feat that required great powers of imagination.

The hell from the right panel of *The Garden of Earthly Delights* is among Bosch's most innovative and complex. In this detail, we see musical instruments that have become monstrously oversized and mutated to perform their role as "instruments" of torture. Two men are caught on the hybrid lute/harp on the left, with one tied up on the instrument's neck, while another is impaled on the strings. Next to them is an equally terrifying hurdy-gurdy/bagpipe mutant, with a nun-like woman being mangled inside it while attempting to play a triangle. Below the lute/harp, another sinner has had musical notations branded on his buttocks. Music was often associated with courtly life in the Renaissance, especially when it involved written notation and refined instruments such as the lute and harp. Bosch's patron, probably Count Henry III of Nassau, would have recognised the "follies" of his own class in these details. He would also have noticed the follies of ordinary people in Bosch's work. The "hell" panel of *Earthly Delights* takes special aim at carnival festivities, when working class townsfolk could mock and ridicule the social elite. Such festivals often involved folk music instruments, including the hurdy-gurdy, bagpipes and drums, as well as boating and other water sports, like those seen at the top right corner of this detail. Carnival was also becoming increasingly raucous and violent in the Netherlandish world of 1500. For Bosch and his wealthy clients, such activities were now worthy of reprimand in art.

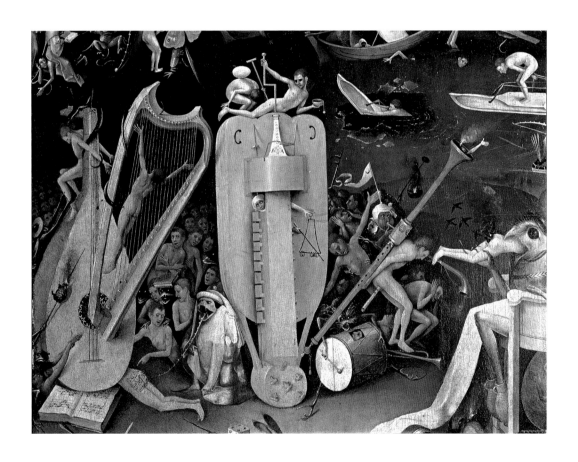

The Garden of Earthly Delights (closed panels), c.1495–1505

Oil on oak panels
Left panel 187.5 × 76.5 cm, central panel 190 × 175 cm, right panel 187.5 × 76.5 cm
Museo Nacional del Prado, Madrid

"For he spoke, and it came to be; he commanded, and it stood forth."
(Psalm 33:9)

The Garden of Earthly Delights has been displayed at the Prado Museum in Madrid since 1939, and for much of that time visitors have been able to see the triptych in its fully opened state. For most of the painting's history, however, it was kept in private royal collections, first in the palace of the Counts of Nassau in Brussels and then, from 1593, in the Escorial palace and monastery outside of Madrid. During these centuries, the triptych was closed for most of the year, revealing a very different composition on the outer side (or closed side) of the left and right panels. Surprisingly, this image is also part of *The Garden of Earthly Delights*. It represents the creation of the world in grisaille, or shades of grey paint. Its sombre colours reflect the mysterious nature of its subject matter. Bosch's image of God the Creator is barely visible through clouds in the upper left corner of the painting; and he inscribes the words of Psalm 33, which hails God's work, in Gothic lettering across the top of both panels. Instead of emphasising God's presence, as most painters of his day would have done, Bosch makes the focus of his image the primordial earth itself. This newly conceived world is contained in a sphere, almost like a living creature in its amniotic sac before birth. The "fluid" inside that sac is already forming recognisable trees, rocks, hills and fruits — a bubbling stew beginning to cool and take shape. Bosch creates these primeval elements with the same whimsical freedom that we see in the rest of his painting, and they show the artist's unusual fascination with nature.

Bosch's mystical, sober creation panels barely hint at the extravagant, sensual fantasies hiding inside. By providing such a dramatic contrast between the external and internal triptych, Bosch heightened the emotional impact that viewers would experience when seeing the triptych opened—an experience rarely offered to modern-day museum visitors.

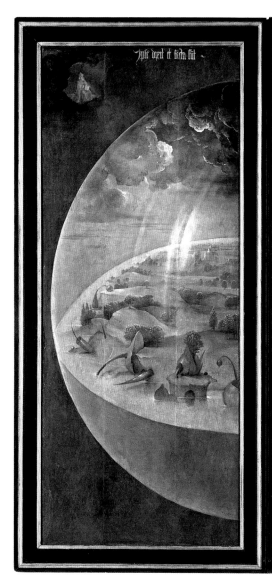

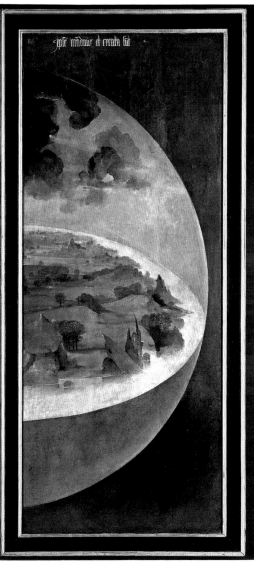

49

Ecce Homo, c.1475–1485

Oil on oak panel
71.4 × 61 cm
Städel Museum, Frankfurt am Main

This small painting, probably made for a donor family, has long been grouped among Bosch's earliest surviving artworks. The most recent evidence suggests that it may date from as early as the 1470s. The subject of the image, an important scene in the Passion of Christ, depicts Jesus after he has been beaten, bound with shackles, and crowned with thorns. The Roman governor Pontius Pilate, shown here in a red cloak, now parades the humiliated Christ in front of an unruly mob. Pilate's sneering words, "Ecce Homo" (or "Behold the Man") can be seen in physical form coming out of his mouth. In the 1930s, analysis of the painting identified the presence of donor portraits. The male members of the donor family kneel in the lower left corner, while the female members kneel in the lower right. These portraits had been painted over, perhaps not long after Bosch's death, and they were restored in incomplete form during the 1980s. Among the male donors, which are better preserved than the female ones, a figure of a Dominican monk (possibly a family member as well) is imploring Jesus: "Save us, Christ the Redeemer"—words that also appear in physical form in Gothic lettering. Bosch scholars note that the donor figures are dressed in sober, modest fashion, which separates them visually and spiritually from the brightly coloured sinners.

Unlike Bosch's more mature works, this image presents its characters with rather stiff, caricatured faces and bodies. Other parts of the work are more expertly painted. The atmospheric cityscape in the background resembles similar images by Jan van Eyck, with its delicately painted architecture, credible sense of space, and playful details such as the couple bending over the bridge and gazing into the dark river below. These differences in artistic quality suggest a painter still perfecting his style and technique.

Though *Ecce Homo* is an early work, it includes elements that would become characteristic of all Bosch images, such as the giant toad that decorates a man's shield and the owl that peers quietly though the tiny window above Christ and the mocking crowd.

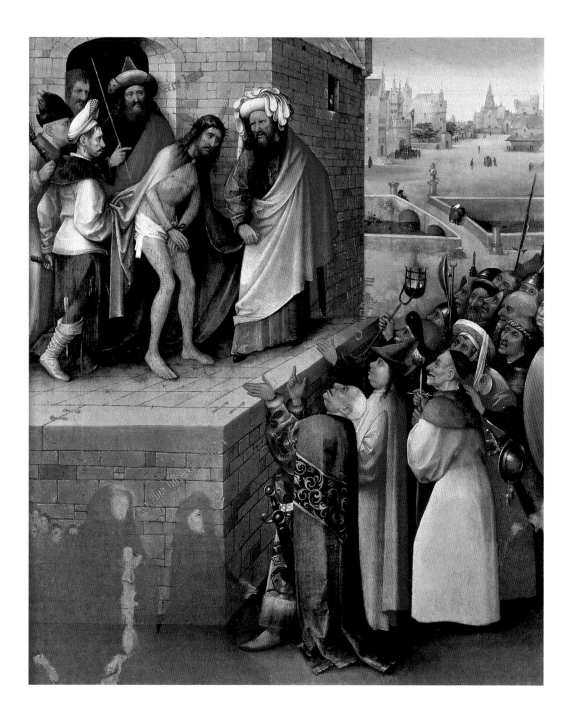

Saint John the Baptist, c.1490–1495

Oil on oak panel
45.8 × 40.5 cm
Museo Fundación Lázaro Galdiano, Madrid

"John did baptise in the wilderness, preaching a baptism of repentance for the forgiveness of sins. And there went out to him all the country of Judea, and all the people of Jerusalem; and they were baptised by him in the river Jordan, confessing their sins. Now John was clothed in camel's hair, and had a leather girdle around his waist, and ate locusts and wild honey."
(Mark 1:4–6)

John the Baptist, the man who baptised Jesus and a man of "the wilderness," offered Hieronymus Bosch a perfect human subject for his art. Bosch's talent for depicting the beauty and mystery of nature was unmatched in his time, and this image of Saint John features a particularly impressive landscape à la Bosch. The saint reclines on a rocky outcrop, gazing at the Mystic Lamb, a symbol of Christ. Behind him stretches an eerie terrain charged with energy. Its shimmering trees are cloaked in mist, and in the far distance stands an outlandish mountain composed of stone, trees and ruined architecture. This rocky detail has an anthropomorphic quality, watching over its realm like a sentinel. But the most dramatic element in John's world is the twisting, spiky plant in the foreground, which nearly upstages the saint himself. Its bulbous, gourd-like fruits appear ominous, yet they offer a source of nourishment for the tiny birds. Scholars have long been attracted to this odd creation, ascribing to it various symbolic meanings. In 1996, however, infrared analysis of the underdrawing revealed that the plant had a more practical function for Bosch. He used it to cover up an earlier image of a donor. Other surviving Bosch works also include donor images that were overpainted, possibly because the donor died and the work ended up being revised for another client.
Recent scholarship suggests that this painting may have been part of a grand altar-piece for the chapel of the Brotherhood of Our Lady in s'Hertogenbosch. The altar-piece combined sculptural and painted decoration, some of which may have been undertaken by Bosch's workshop. But, as with many of the artist's surviving works, there is no definitive evidence linking the painting to a particular client or location.

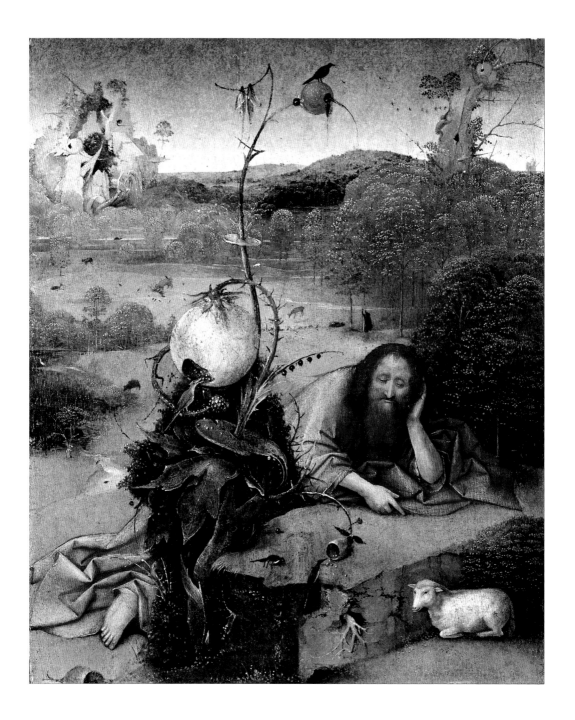

The Pedlar, c.1500–1510

Oil on oak panel
71.3 × 70.7 cm
Museum Boijmans Van Beuningen, Rotterdam

Some of the most recognisable works by Hieronymus Bosch have only survived in mutilated form. This poignant image of a struggling wayfarer is now believed to be part of a larger triptych that illustrated the Christian "pilgrimage of life." Analysis of the wood of the panel shows that it came from the same tree as three other surviving paintings by Bosch: *The Ship of Fools*, the *Allegory of Intemperance* and *Death and the Miser*. Initially, *The Pedlar* was meant to be seen on the outside of the triptych, much like the similar wayfarer image from the *Haywain*.

In his pioneering book, *Hieronymus Bosch: his picture writing deciphered*, published in 1948, Dirk Bax analysed this and other Bosch works with unprecedented thoroughness. Pointing to specific details in *The Pedlar*, he argued that they were inspired, in part, by the popular culture of Bosch's era. For example, when asserting that the caged magpie hanging outside the ramshackle house was a symbol of prostitution, Bax cited a sixteenth-century rhyme: "The magpie has sweet things to say, but all your pence is took away."

Bax then goes on to describe his overall impression of the work: "The man is a pedlar impoverished by his addiction to drink. This vice prevents him from bettering his life. He has indeed avoided the inn of easy virtue and withstood the allurements of lust, but he knows very well (as his sad smile of self-knowledge shows) that he cannot break himself of the habit ... Indeed, he is fully conscious of the fact that he is improvident and given to sin. For a moment the sadness of it all wells up within him, but then self-ridicule helps him to overcome it.

The Pedlar's countenance is the most striking feature of the picture. Bosch has made it express a mingling of wistfulness, zest for life, indifference, shiftlessness, self-ridicule and, not least, self-knowledge. ... the artist has imbued it with transcendental meaning: the pedlar becomes Man going through life as a wanderer, capable one moment of resisting temptation, but the very next finding himself floundering in some other evil, yet counting himself lucky if he discovers that self-knowledge and self-ridicule are part of his heritage. This is why the panel is the most human of all Bosch's works and moves us so deeply."

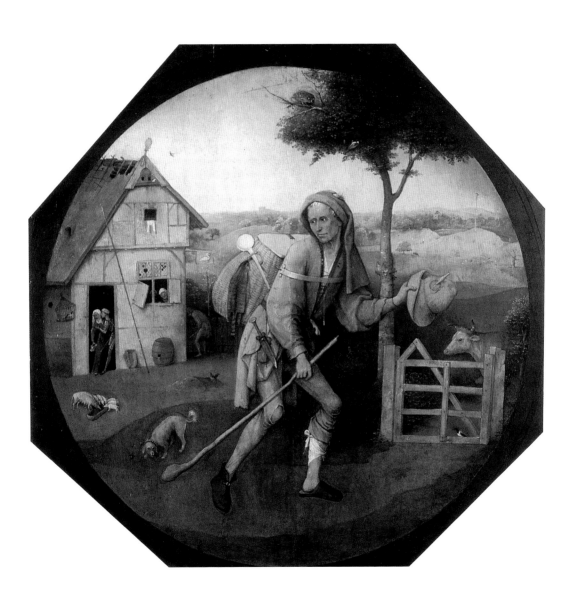

The Haywain, c.1500–1516

Oil on oak panel
Left panel 136.1 × 47.7 cm, central panel 133 × 100 cm, right panel 136.1 × 47.6 cm
Museo Nacional del Prado, Madrid

"The idea and the ingenuity of these paintings are based on the passage in Isaiah, where God has him cry out: 'All flesh is grass and all its glory is like the flower in the field.' To which David says: 'Man is like grass, and his glory is like the flower in the field.' One of these … (consists) of a large painting and two wings with which they can be closed. On the first of these shutters, he (Bosch) painted the creation of man and how God placed him in paradise, … and how he commands him as a test of his obedience and faith not to eat of one tree. And how the devil in the form of a serpent then misleads him … The large painting that follows shows how man, banished from paradise and placed in this world, occupied himself. It depicts him pursuing a glory of hay and straw, or of grass without fruit, which exists today and is thrown into the oven tomorrow, as God Himself said. In this way, it depicts the lives, occupations and conduct to which these children of sin and wrath succumb … to seeking and pursuing the glory of the flesh that is just as transient, finite and useless as hay, because such are the gifts of sensuality, status, ambition and fame.
This haycart, on which glory rides, is drawn by seven wild beasts and terrifying monsters, including human beings who are half lion, others half dog, others still half bear, half fish and half wolf—all symbols and representations of pride, lust, greed, ambition, bestiality, tyranny, cunning and cruelty.
Around this cart walk all ranks and estates of man, from the pope and emperor and other princes to those who stand in the lowest esteem and have the world's worst occupations; because all flesh is hay, and the children of the flesh arrange everything and use everything to achieve this vain and transient glory; and everything revolves around thinking of how they might ascend to the glory of the cart: some use ladders, others have hooks, others clamber, others jump and seek as many means and instruments as possible just to get on top of it; some, who were already on it, fall off; others are run over by the wheels, …
The final destination of all this is shown in the last wing, in which a very frightening hell can be seen, with strange torments, terrifying monsters, all shrouded in darkness and eternal fire. And to make clear the large band of people who enter there and for whom there is no longer any room, he imagines that new quarters and rooms are being built; and the stones that are laid are the souls of the damned; and the same means they used to achieve glory have been turned here into instruments of their punishment."
(from José de Sigüenza's *History of the Order of Saint Jerome*, c.1605)

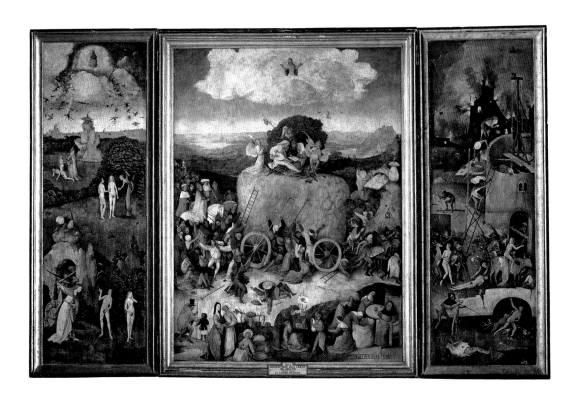

The Haywain (closed panels), c.1500–1516

Oil on oak panel
Left panel 136.1 × 47.7 cm, central panel 133 × 100 cm, right panel 136.1 × 47.6 cm
Museo Nacional del Prado, Madrid

"Now this stick we might call a staff, such as pilgrims carry when they take the back
roads and in many a town to chase away the dogs. We too need such a staff, by
which I mean God, who is the staff we all clutch so that we do not fall from grace.
It serves us, moreover, at every hour to ward off the hounds of hell."
(from *The Mirror of Human Salvation*, an anonymous fourteenth-century theological
text)

On the closed panels of Bosch's *Haywain* tryptych, the artist painted a vignette
very similar to *The Pedlar*. Once again, a wandering, bearded man travels along a
road of uncertainty and potential danger. He has passed scenes of gaiety, such as
the dancing couple and bagpipe player, and he has also witnessed a fellow traveller
being attacked by robbers. Now, as in *The Pedlar*, he must face an angry dog with a
spiked collar. This "hound of hell" is even more aggressive and threatening, and he
is surrounded by eerie bones and raven-like birds—images of death. But the wan-
dering man does not fear the challenges in front of him. His torn clothes and aging
face indicate a life of struggle and perseverance.
Historians note that this character is somewhat unusual for Bosch: a social outcast
whom the artist presents in a positive light, and who represents the same spiritual
determination as Saint Anthony or Saint Jerome. This wayfarer's journey is meant to
be seen in contrast to the frivolity, avarice and lust of those following the "haywain"
(or haycart). With his backpack and walking stick, the aging man makes his way
across a bridge and into a future that neither he nor the viewer is allowed to see.
According to recent scholarship, the *Haywain* triptych may have been painted at
the end of Bosch's life, probably later than *The Pedlar*. The wayfarer, therefore, is
probably a modified version of the earlier work. In many successful workshops of
Bosch's era, images could be re-used several times if they proved successful. Such
images could become closely associated with the artist and help to "advertise" his
work.

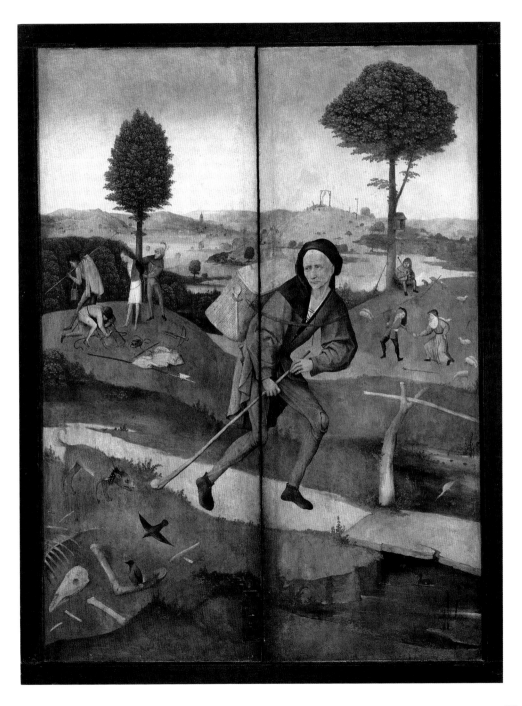

The Temptation of Saint Anthony, c.1500–1510

Oil on oak panel
Left panel 144.8 × 66.5 cm, central panel 145.1 × 132.8 cm,
right panel 144.8 × 66.7 cm
Museu Nacional de Arte Antiga, Lisbon

"Sometimes he (Hieronymus Bosch) painted Temptations of Saint Anthony ..., as this
was a subject in which he could show strange effects. On the one hand, we see the
holy prince of hermits with a serene, devout, contemplative and calm face, and a
soul filled with peace; on the other, there are the countless fantasies and monsters
created by the enemy to confuse, worry and disturb this mild soul and steadfast
love. To this end, he created wild beasts, chimeras, monsters, fires, corpses, cries,
threats, serpents, lions, dragons and terrifying birds of so many varieties, that it is
admirable how he was able to give shape to so many ideas."
(from José de Sigüenza's *History of the Order of Saint Jerome*, c.1605)

Hieronymus Bosch made several versions of *The Temptation of Saint Anthony*, the
most famous of which is a triptych at the Museum of Ancient Art in Lisbon. This
painting may not be the one described by José de Sigüenza in about 1605. But the
Spanish author and poet accurately captures an essential feature of all Anthony
paintings by Bosch—the contrast between the stoic character of the saint and the
tumultuous world around him.
Bosch's "wild beasts" in the Lisbon *Temptation* rank among his most energetic and
imaginative. They soar, march and swim from one panel to another in their attempts
to torture Saint Anthony and deter him from his spiritual mission. The artist employs
a striking variety of animal, plant, machine and human parts to construct his demons'
bodies—heightening their eerie, destructive appearance without making them
seem artificial. Bosch also uses landscape to achieve his aesthetic effects. The greyish
ponds and lakes appear noxious and thick with waste, and the rocky terrain is largely
bereft of plant life. The buildings, too, have an alien, forbidding quality. Some have
been reduced to ruins, while others are stripped of ornament and have a fortress-like
appearance. As much as any painting by Bosch, this work uses the devastating imag-
ery of warfare to convey the inner battles of the spirit.

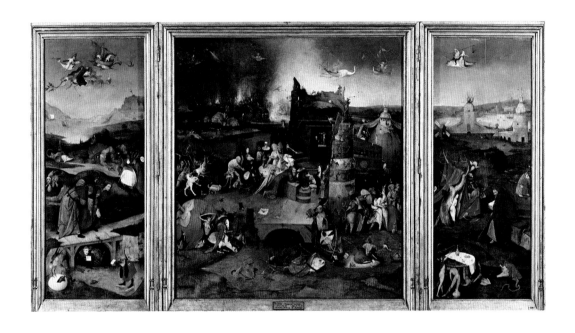

The Temptation of Saint Anthony (detail of left panel), c.1500–1510

Oil on oak panel
Left panel 144.8 × 66.5 cm, central panel 145.1 × 132.8 cm,
right panel 144.8 × 66.7 cm
Museu Nacional de Arte Antiga, Lisbon

"A devil-messenger gives three devils under a bridge a letter to read, which contains a protest, ostensibly by Antonius, against the ill treatment he is receiving at the hands of his tormentors. ... The saint, who is here presented as the master whom the messenger serves—Antonius's initial appears on the messenger's badge—is therefore being mocked.... In this little devil Bosch censures various sins. The funnel on his head signifies, among other things, intemperance and wastefulness; the dry twig with the small red ball, licentious merrymaking; the long ears, foolishness, among other things; and the cockspur on his calf, addiction to drink. The cracking ice and the skates under his feet indicate, respectively, that he finds himself in a dangerous situation and that things are going amiss with him."
(from Dirk Bax's *Hieronymus Bosch: his picture-writing deciphered*, 1948)

Dirk Bax was among the first historians to immerse himself in the study of Bosch's complex, multi-layered symbolism. He revealed how Bosch could illustrate in a single character, such as this bird-like "devil messenger," a multitude of sins that contemporary viewers would easily recognise. Allegory was a common tool in fifteenth-century European art, but few other painters were as effective as Bosch at using symbols to tell stories.
Bax goes on to interpret other characters in this scene by the bridge. The oversized red-headed bird, a species of bittern, is devouring chicks that are hatching out of an egg below it. The bittern was an image of gluttony in the Middle Ages, a bird that had two stomachs and was "very voracious." Under the bridge we see a cleric with a blue hood that symbolises unreliability; a dancing bear representing unchaste behaviour; and a water-rat embodying deceit and stupidity. Saint Anthony must "escape" the sins embodied by these characters, even though he has recently been attacked by demons and is physically broken. Bosch shows Anthony being carried away by monks over the bridge, while a beastly bagpiper plays a "funeral march" behind him. As Bax asserts, characters such as the bagpiper had their origins in Carnival festivities; and "Bosch knew Carnival as a festival full of excesses."

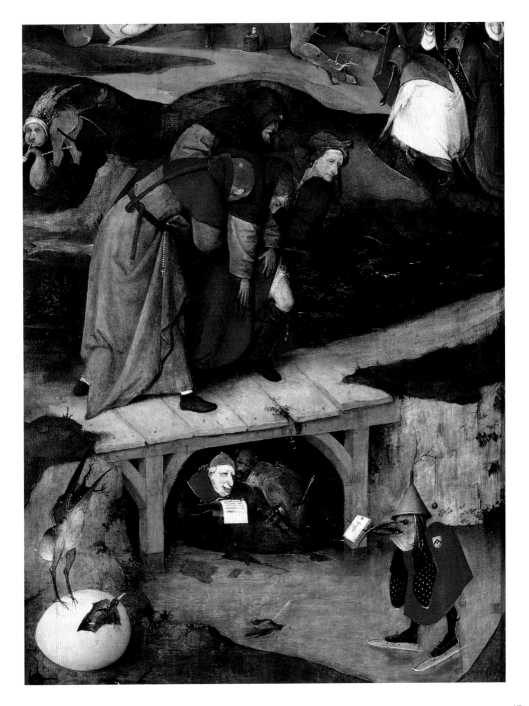

The Temptation of Saint Anthony (detail of central panel), c.1500–1510

Oil on oak panel
Left panel 144.8 × 66.5 cm, central panel 145.1 × 132.8 cm,
right panel 144.8 × 66.7 cm
Museu Nacional de Arte Antiga, Lisbon

In the central panel of Bosch's *Temptation of Saint Anthony*, a swirling mass of demons surrounds the kneeling saint as he turns his head to the viewer and raises his hand in a two-fingered sign—a gesture intended to exorcise the sinful creatures. The detail shown here captures a wide array of infernal behaviour. Three devils on the left are reading a book, which they probably stole from Anthony. According to historian Dirk Bax, "The foremost cleric has the head of a sheep, which signifies ... unchastity and stupidity. His robe is rent and through the opening we see a body in a state of decomposition and with the bones already showing. Spirit and flesh alike are putrefied by evil." The two demons behind him are dressed as monks, and together the three figures present a devastating caricature of lazy, corrupt Church authorities.

Bosch also ridicules the follies of the poor. The blue-faced peasant woman on the giant rat has a scaly tail and a head encased in a tree trunk. She holds out a small child, probably parodying the beggars who deceitfully use other people's children to seek alms on holy days. Next to her, another beggar with birds' wings sits astride a horse that possesses a wine-jug for a backside—an image of gluttony and drunkenness. Below this mounted group we see a duck-shaped boat inside which a drunken monk is singing. Steering the boat is a beggar with dark skin and a clubfoot, signs that he may be unchaste and cursed by God. But the strangest peasant creature of all may be the man in the upper left corner, who has a giant head and legs but no torso. This "bodiless" figure sticks his leg out to reveal an empty mug on his knee, indications of his need for charity and drink.

The depraved nature of Saint Anthony's world is further emphasised by the turbid water and the ruined buildings. On the rounded wall, Bosch creates highly detailed friezes that show images of hounds, monkeys, drums and grapes, all of which may be linked to gluttony, licentiousness and other sins. This decaying environment—the worldly concerns that weigh down the soul—must be confronted and overcome by the steadfast saint.

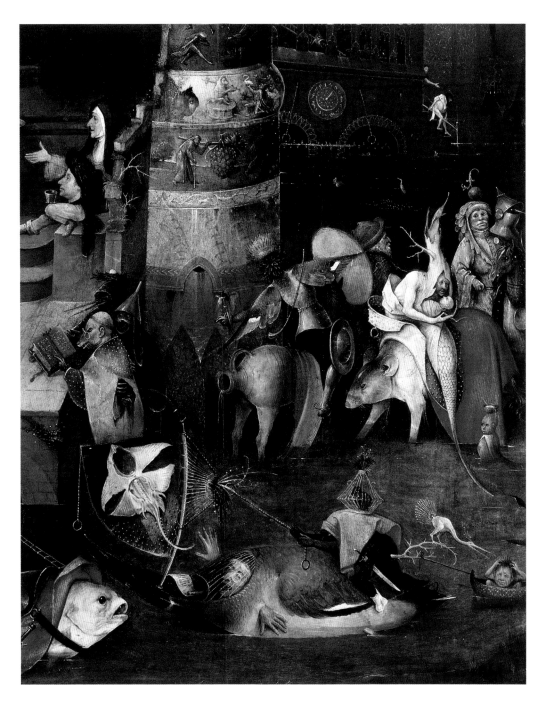

The Temptation of Saint Anthony (detail of right panel), c.1500–1510

Oil on oak panel
Left panel 144.8 × 66.5 cm, central panel 145.1 × 132.8 cm,
right panel 144.8 × 66.7 cm
Museu Nacional de Arte Antiga, Lisbon

"After this event the hermit went still further into the wilderness, until he came to a stream in which were bathing a beautiful queen—the form in which the Evil One had now disguised himself—and her court ladies. His modesty shocked, he was about to turn back, but the woman implored him to remain..."
(from the *Vaderboek*, c.1490)

The right panel of Bosch's *Temptation of Saint Anthony* illustrates another kind of spiritual test. Anthony confronts a beautiful, unclothed woman who tries to tempt him into carnal sin. This part of the story was included in the *Vaderboek*, a collection of saints' lives published during Bosch's lifetime. In the book, the woman is described as a devil who takes the shape of a queen, and who meets Anthony in the wilderness while swimming with other ladies of her court. Bosch, however, presents the devil-queen more like a harlot. Her courtly entourage has been replaced by demons, a hollow tree and a grey, murky swamp. An older lady dressed rather like the Virgin Mary pours wine into a bowl, which is held aloft by a toad-like monster with insect wings. For Dirk Bax, this "anti-Mary" plays the role of a madam, offering the sexual services of her best employee. Other details, including the voluptuous red curtain and the lewd cat-devil underneath, further emphasise the base nature of this temptation.
Bosch depicts Anthony with his head turned away from the temptress, but the saint's eyes and mouth suggest tension and uncertainty over whether or not to accept her offer. In the *Vaderboek* story, Anthony does not reject the queen at first, but goes with her to the magnificent city where she reigned. While there, she makes another attempt at seduction. But as the story reveals, "When she proceeded to lay hands on him and wanted to tear from him the robe of his order, it became clear to him at last that she was the devil and he called for the help of Christ. Immediately the fair one changed into a black pig."

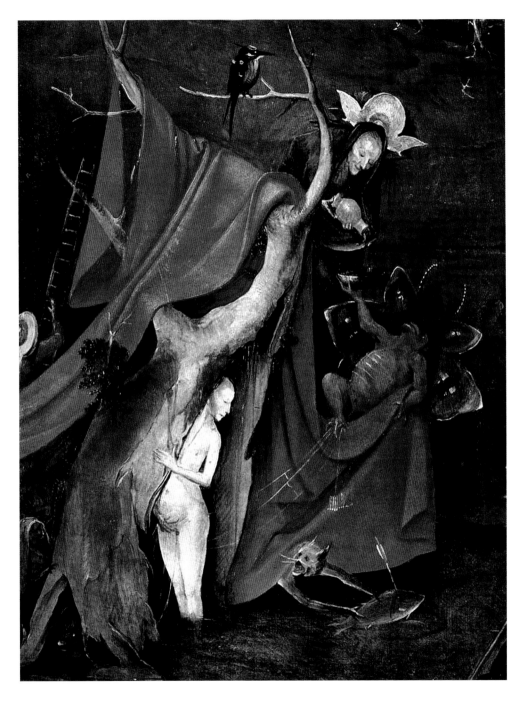

The Ship of Fools, c.1500–1510

Oil on oak panel
58.1 × 32.8 cm
Musée du Louvre, Paris

"For fools a mirror it shall be,
Where each his counterfeit may see.
His proper value each would know,
The glass of fools the truth may show.
Who sees his image on the page
May learn to deem himself no sage, ..."
(from Sebastian Brant's *Ship of Fools*, 1494)

Along with *The Pedlar*, *The Allegory of Intemperance* and *Death and the Miser*, Bosch's *Ship of Fools* once belonged to a larger triptych that was dismantled and mutilated, possibly in the early nineteenth century. Different pieces of the triptych ended up in different locations, with *The Ship of Fools* now displayed at the Louvre Museum in Paris. *The Ship of Fools* represents only two-thirds of the triptych's original left panel, the bottom third being *The Allegory of Intemperance* (page 71), now at the Yale University Art Gallery in New Haven, Connecticut. But despite its fragmentary state, the Louvre painting still conveys a strong, cogent message.
A group of revellers, including a monk and nun, have crammed themselves into a rather shaky boat with a tree branch for a mast. Yet they seem unconcerned about the danger, as they have installed a large plank topped with food and drink that extends outside the boat and seems to increase its instability. Naked swimmers approach the ship looking for a handout, while a jester sits on another tree branch on the right side of the boat. Clearly, foolishness and gluttony are important themes of this work, although other details may represent different concepts. The cherries on the makeshift table, for example, may symbolise lust; and the owl that rests on top of the mast and overlooks the scene may allude to the revellers' uncertain future.
Bosch's unsteady boat may have been influenced by another "Ship of Fools", a popular book of poetry and etchings that was published by German author Sebastian Brant at the end of the fifteenth century. Brant humorously explored the many ways people could devolve into foolishness, and he stressed the need to recognise and overcome one's own indiscretions. Bosch probably designed his triptych to convey the same message. Recent scholarship has found that he placed the *Ship of Fools* panel, a scene of youthful irresponsibility, across from *Death and the Miser* (page 73), an image of regret and judgement at the end of life.

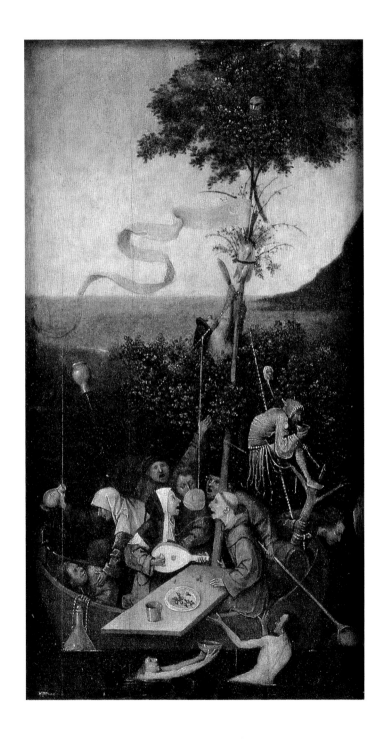

The Allegory of Intemperance, c.1500–1510

Oil on oak panel
34.9 × 31.4 cm
Yale University Art Gallery, New Haven

"Into the fool's ship toss the ape,
He kills all reason, is not sage,
And he will regret it in old age.
His head and hands will ever shake,
His life a speedy end may take,
For wine's a very harmful thing,
A man shows no sound reasoning
Who only drinks for sordid ends,
A drunken man neglects his friends
And knows no prudent moderation,
And drinking leads to fornication;
It oft induces grave offence,
A wise man drinks with common sense."
(passage from "Of gluttony and feasting" in Sebastian Brant's *Ship of Fools*, 1494)

Long known as *The Allegory of Intemperance*, this painting is in fact the bottom portion of a triptych panel that also contained *The Ship of Fools*. In the 1990s, dendrochronological analysis of the tree rings in both panels confirmed that the wood came from the same tree. Today, scholars often interpret this image, together with *The Ship of Fools,* as deriding gluttony and foolishness. The *Intemperance* scene shows a man floating in a barrel, which appears to contain wine or beer. Naked swimmers, as well as a hooded man, push the barrel forward and take their fill of its contents. The man riding the barrel wears a funnel hat, a sign of stupidity; he also carries a branch and plays a long wind instrument. Below him, another naked swimmer balances a plate holding a meat pie with a bird head sticking out of its top. People in Bosch's day would have recognised these characters as celebrating the spring festival, or May festival, which was well-known for partying and love-making. They would also have recognised the details at the bottom of the image—the discarded clothes and the intimate scene between the man and woman in the tent—as representing the sinful "fornication" that can result from over-indulgence.

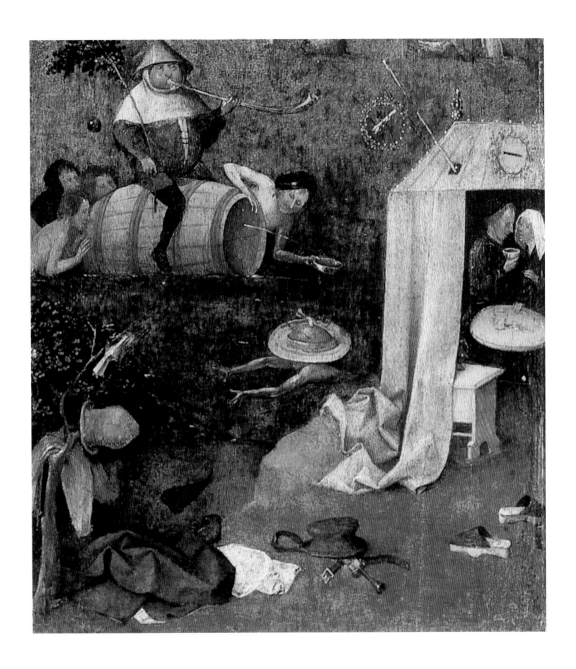

Death and the Miser, c.1500–1510

Oil on oak panel
94.3 × 32.4 cm
National Gallery of Art, Washington, D.C.

The dismembered Bosch triptych that contained this painting, along with *The Ship of Fools* and *The Allegory of Intemperance*, is sometimes called *The Wayfarer Triptych*. *Death and the Miser* was originally the right panel of the triptych. A dying man has spent his life acquiring wealth and worldly contentment. His elegant room boasts of decorated columns, a vaulted ceiling and a gracious bed. His gold and trinkets can be seen in the chest in front of his bed, into which a healthier old man (possibly an image of the miser from a few years before) is adding still more gold coins. The giant lock on the chest further expresses the man's avaricious nature. Below, a spear and pieces of armour lie strewn on the floor, which may symbolise the false sense of power achieved from jousting and other sports. Clearly, this is someone who has held "fortune's wheel" tightly.

Bosch, however, does not make the man's fate entirely clear. Even though the ghostly figure of Death can be seen with his arrow at the door, and demons swarm about his room and belongings, the miser appears to have a last chance at salvation. A winged angel kneels behind him and pleads for mercy from Jesus, who is represented by the tiny crucifix in the window above his bed. At the same time, an ineffectual demon offers the man a sackful of gold. The old miser appears undecided as to what he should do. His right hand gestures toward the bag of money, but his eyes appear to be moving away from his worldly endeavours and toward Christ. What will his decision be? Bosch suggests here that salvation remains possible as long as we have a chance to repent our sins. In this way, he followed the tradition of *Ars moriendi* illustrations, popular in his day, which taught people the "art of dying" before they succumbed to God's hands.

Scholars who have studied the *Wayfarer Triptych* believe that the surviving panels flanked a large central panel of the Last Judgement. For Bosch, a hellish afterlife was waiting for those who committed gluttony, avarice and other sins and remained unrepentant.

Saint Christopher, c.1490–1500

Oil on oak panel
113.7 × 71.6 cm
Museum Boijmans Van Beuningen, Rotterdam

"And then Christopher lifted up the child on his shoulders, and took his staff, and entered into the river for to pass. And the water of the river arose and swelled more and more: and the child was heavy as lead, and always as he went farther the water increased and grew more, and the child more and more waxed heavy, insomuch that Christopher had great anguish and was afraid to be drowned."
(from the *Golden Legend*, a collection of saints' lives compiled by Jacobus de Voraigne, 1275)

Saint Christopher, the patron saint of travellers, was immensely popular in fifteenth-century Europe. Most people in Bosch's day were familiar with his story from the *Golden Legend*, a thirteenth-century compilation of saints' lives. The tale described Christopher as a giant, more than 7 feet (2.1 meters) tall, who was searching for the world's most powerful king. After learning that all earthly kings were afraid of the devil, and that the devil himself was afraid of Jesus Christ, Christopher asked a Christian hermit how he could find and serve Jesus. The hermit told him: "Because thou art noble and high of stature and strong in thy members, thou shalt be resident by that river, and thou shalt carry over all them that shall pass there, which shall be a thing right amenable to our Lord Jesus Christ whom thou desirest to serve, and I hope he shall show himself to thee."
After following the hermit's advice, Christopher was approached by Jesus, who appeared to him in the form of a child and asked him for assistance across the river. The child proved to be heavier than expected, and Christopher barely survived the crossing. Christ then revealed himself to the giant and told him: "thou hast not only borne all the world upon thee, but thou hast borne him that created and made all the world, upon thy shoulders." Jesus then blessed the saint and made his wooden staff bear "flowers and fruit."
Bosch depicts Christopher's story at its most dramatic moment: in the middle of his dangerous crossing. The giant's huge frame is buckling in the river, and he still does not recognise the identity of his passenger. To heighten the feeling of danger, Bosch adds background details such as the hanging bear, the bizarre pottery tree house (probably the home of the hermit), and the naked man who is fleeing a dragon that appears out of a ruined building. The painter also gives the viewer hints as to the outcome and purpose of the story. The dead fish hanging from Christopher's staff may represent the crucified Christ who bore the world's suffering, while the greenery sprouting from the staff foreshadows Jesus's blessing to the saintly giant.

Saint Jerome, c.1485–1495

Oil on oak panel
80 × 60.7 cm
Museum voor Schone Kunsten, Ghent

"And yet nevertheless I was oft fellow unto scorpions and wild beasts, and yet the
carols of maidens and the embracements of lechery grew in my cold body and in
my flesh, wherefore I wept continually, and for to ... subdue my proud flesh I rose at
midnight all the week long, ... and I ceased not to beat my breast, praying our Lord
to render to me the peaceable peace of my flesh."
(from the *Golden Legend*, a collection of saints' lives
compiled by Jacobus de Voraigne, 1275)

Jerome, or Hieronymus, was the saint after whom Bosch was named. An early
Christian theologian, he translated much of the Bible from Hebrew into Latin. The
story of Jerome often focuses on his years in the Syrian desert, where he repented
for the sexual escapades of his youth and his other sins. To purify his soul, the
saint endured severe fasting and loneliness, as well as self-flagellation with rocks.
Jerome's spiritual journey was highly admired in fifteenth-century northern Europe.
The popular *Devotio Moderna* (or Modern Devotion) movement of the time encour-
aged people to follow Jerome's example through prayer, meditation and the cleans-
ing of impure thoughts.
We can see Bosch's profound connection to Saint Jerome in this passionate image.
Unlike most artists of his era, Bosch does not show the saint beating his chest with
rocks. Here, the flagellation has already occurred and the rock lies on the ground.
Bosch focuses instead on Jerome's internal struggle, depicting him in prostrate
form with his hands in prayer and his arms cradling a wooden crucifix. The focused
expression on Jerome's face reveals a man completely engaged in thought. He is
unaware of his ominous surroundings—the tombstone above his head, the watch-
ful owl, the bizarre plant life growing out of the rocks and the floating dead in
the murky water. These images suggest the dangers of an unclean soul, and they
contrast sharply with the "untarnished" white cloth of Jerome's tunic and Christ's
loincloth on the crucifix. They also contrast with the landscape beyond, where we
see cultivated fields, green hills and a church nestled in the trees. Bosch's verdant
countryside may symbolise the spiritual calm that is earned by Jerome's painful
inner journey.

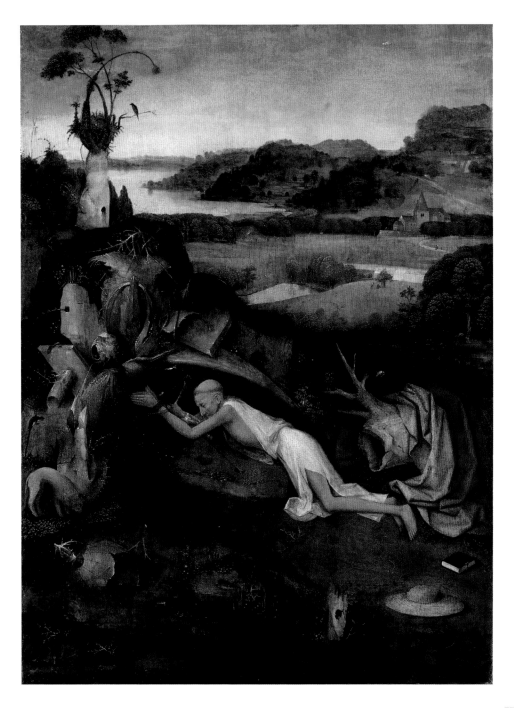

Saint John on Patmos, c.1490–1495

Oil on oak panel
63 × 43.2 cm
Staatliche Museen zu Berlin, Berlin

The story of Saint John the Evangelist tells of his exile from Rome, where he had been preaching Christianity against the wishes of the Roman Emperor Domitian. John was sent to the remote Greek island of Patmos. While there, he received a vision from heaven, "a woman clothed with the sun, with the moon under her feet, and on her head a crown of twelve stars." A series of other visions would follow, revealing to John the Apocalypse: the destruction of the old world and the second coming of Christ as ruler of the new world. According to tradition, John would record these experiences in the Book of Revelation in the New Testament.

Saint John the Evangelist was also the patron saint of Bosch's home church, the church of St. John in s'Hertogenbosch. Recent assessment of this painting, moreover, suggests that both it and *Saint John the Baptist* (page 53) were made for a large altarpiece in the church's Brotherhood of Our Lady chapel.
Bosch once again displays his talent for portraying spiritual moments in the "wilderness." He renders Patmos as a grand, peaceful setting, with a Gothic cityscape that resembles medieval Flanders more than it does ancient Greece. As he did in *Saint Christopher*, Bosch illustrates an important moment in the action of the story. John has just been disturbed from his writing by the "woman of the Apocalypse," along with a blue angel that directs the Evangelist to her presence in the sky. Bosch's heavenly woman has the moon at her feet and the stars on her head, as described in Revelation. She also wears the Virgin Mary's blue robe and holds the Christ Child in her lap, symbolising the new world to come. Below John, a part-human, part-insect devil with a fiery bowl on his head looks sheepishly at an eagle, the Evangelist's symbol. He has dropped his weapon on the ground, possibly in fear of the cataclysmic events being revealed to John. Bosch uses colour here to distinguish the blessed from the damned, rendering the heavenly figures in ethereal blue, the Evangelist in soft pink, and the ineffectual demon in earthy grey.

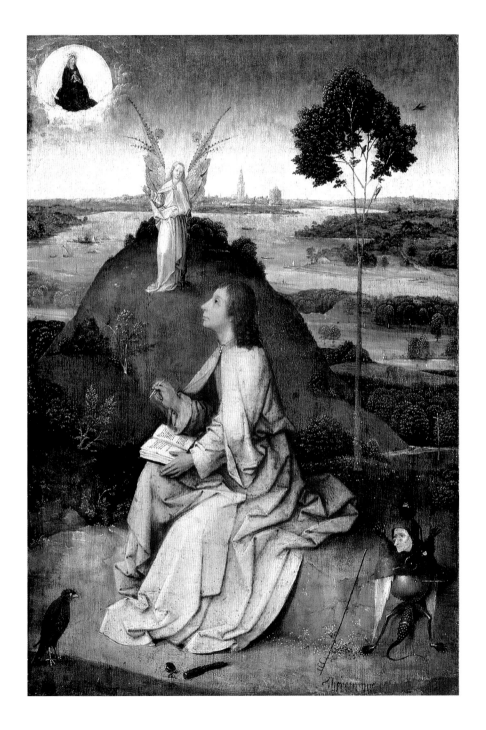

Saint Wilgefortis Triptych, c.1495–1505

Oil on oak panel
Left panel 105.2 × 27.5 cm, central panel 105.2 × 62.7 cm, right panel 104.7 × 27.9 cm
Gallerie dell'Accademia, Venice

In recent years, infrared imaging techniques have revealed hidden details in Bosch's paintings, enabling us to get a better understanding of his working method. With this painting, however, the recently uncovered details have led to a re-examination of the subject of the image. The triptych has been in Venice for hundreds of years, and it was long believed to represent Saint Julia, an early Christian martyr who was tortured and crucified for refusing to worship pagan gods. In the 2010s, however, infrared analysis found that the underdrawing of the saint's head showed a subtle beard, which may have been obscured on the paint surface by an earlier restoration. Due to this finding, many scholars now believe the painting features another martyr named Saint Wilgefortis.

A popular saint during the medieval and early Renaissance periods, Wilgefortis was a devout Christian princess whose father had promised her in marriage to a Muslim ruler. She rebelled against the marriage by praying for God to make her unattractive so that her intended husband would call off the betrothal. Her prayers were answered when God gave her a man's beard, and the marriage was cancelled. Then, in a rage over his daughter's disobedience to him, Wilgefortis's father had her killed in the same way Christ had died: by crucifixion.

Bosch's triptych shows the Christ-like saint surrounded by a diverse crew of onlookers. Some are emotionally overcome by the event, swooning in front the cross; while others gape at the body as if they were witnessing a carnival performance. Beyond the scene of martyrdom, a hollow tree leads the viewer's eye to a vast landscape with typical Bosch-like elements: the cityscape with church tower and the misty woods and hills in the far distance.

Modern imaging has also revealed significant changes to the side panels of the triptych. Originally, both of these panels had landscapes that matched the central panel, and both had portraits of donors at the bottom. Then, in a subsequent phase of work, the donors were painted over and replaced with a figure of St. Anthony on the left panel and two male figures on the right panel. In addition, the rest of the left panel was reworked to depict a burning city.

Extraction of the Stone of Folly, c.1500–1520

Oil on oak panel
48.8 × 34.6 cm
Museo Nacional del Prado, Madrid

"Master, cut the stone out quickly, my name is Lubbert Das"
(from the decorative inscription in Bosch's *Extraction of the Stone of Folly*)

For Hieronymus Bosch, folly was a key flaw in human character. Few paintings cap-
ture Bosch's obsession with folly better than this witty panel. An older man from the
countryside named Lubbert Das has engaged the services of an unscrupulous travel-
ling surgeon. He desires to have a stone removed from his head. In fifteenth-century
parlance, having a "rock in your head" meant stupidity or mental retardation. Bosch
illustrates his main character's feebleness of mind in the blank, open-mouthed stare
and the lazy, slouching posture. His chosen surgeon is an openly fraudulent quack, a
charlatan that no thoughtful person would employ. The tin hat on the surgeon's head
symbolises his lack of knowledge, as wisdom cannot enter the head though a narrow
funnel; and the empty stoneware pitcher on his belt may betray his desire for a quick
payday. Other figures in the scene carry different symbols of folly and ignorance,
such as the closed book on the woman's head and the beer mug in the monk's hand.
According to many scholars, Bosch's tale of Lubbert Das may involve sexual impo-
tence as well. The "stone" being extracted from his head is, in fact, a water lily, and
the cutting of a flower is often indicative of castration. Moreover, the name "Lubbert"
comes from Middle Dutch words meaning "stupid" and "emasculated", while the
name "Das," or badger, is an animal that was thought to be lazy due to its habit of
sleeping during the day.
Bosch historians also note the unusual composition of *The Stone of Folly*. The round
vignette within a rectangle, along with the elegant descriptive text in gold lettering,
were features common to medieval heraldic panels, which extolled the deeds and
virtues of knights. By mimicking the format of these eulogistic paintings, Bosch may
have intended his work to be seen as a visual parody.

Crucifixion with Donor, c.1490–1500

Oil on oak panel
74.8 × 61 cm
Koninklijke Musea voor Schone Kunsten van België, Brussels

This painting, unusual for Bosch, is a fairly restrained and simple Crucifixion scene that avoids the fanciful details we commonly see in the artist's work. Bosch created the panel for a donor, whose image appears below the Cross. The gentleman is rather fancily dressed, with his black cloak and striped, pink-and-black breeches and stockings—a sartorial figure that contrasts with the bones and the grave characters surrounding him. Saint Peter, the donor's patron saint, stands next to him with the keys of heaven, a symbol of Church authority. He presents the donor to Saint John the Evangelist, holding his gospel book, and a prayerful Virgin Mary, who, according to Catholic tradition, will plead with Jesus for the wealthy man's deliverance.

In the background, we see an idyllic landscape, with a particularly well-detailed medieval city. Modest homes and workshops are jumbled together along the outer wall, while the grander towers and church spires rise behind them. Bosch uses aerial perspective to give his town a feeling of depth. The buildings closest to the viewer are rendered in sharper detail than the hazy, taller structures in the distance. Bosch's landscape also includes his characteristic wooded hills, narrow pathways, and stumpy, hollowed-out trees. Though symbolising Jerusalem, this terrain is clearly medieval Dutch or Flemish in character. It also has a calm, restful mood that reflects the expression of Christ's face.

Such paintings were usually installed in a private chapel, where they could inspire the donor's family to offer prayers for their loved one. A donor portrait could also extol the family's worldly status, especially if the artist was as famous as Bosch.

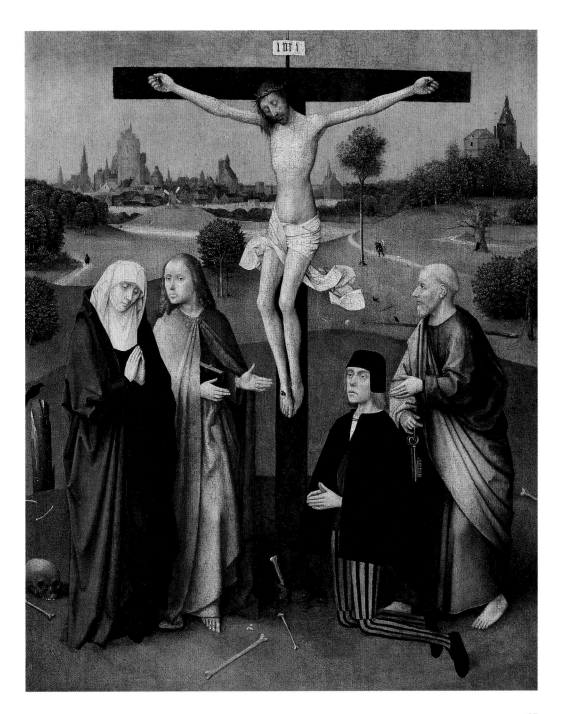

The Crowning with Thorns, c.1490–1500

Oil on oak panel
73.8 × 59 cm
The National Gallery, London

"Then Pilate took Jesus and scourged him. And the soldiers plaited a crown of thorns, and put it on his head, and arrayed him in a purple robe; they came up to him, saying, "Hail, King of the Jews!" and struck him with their hands."
(John 19: 1–3)

Hieronymus Bosch is best known for his storytelling on a grand stage, with his expansive landscapes and demon armies. This painting, however, shows a different side of the painter, one that could render intimate human expression with great sensitivity. Here, we witness in close-up the torture of Christ before his crucifixion. The two "Roman" soldiers hovering above Jesus are shown as cruel hunters and unbelievers. The one in the green tunic uses his armoured hand to place the crown on Christ's head. He carries a blunt arrow, which was used to injure game animals. The other soldier dons a spiked collar typically seen on hunting dogs, as well as an oak leaf in his hat that may symbolise idolatrous pagan gods. Below them, two other men taunt Christ and begin to disrobe him. According to the Gospel of John, on which this painting is based, Jesus receives the crown before his clothes are ripped off and he is forced to wear a purple robe, a symbol of kingship meant to mock the false "King of the Jews". Historians argue that these taunting men are Jews, who are portrayed in the gospels as clamouring for Christ's arrest and crucifixion. Bosch, in fact, paints a Turkish crescent moon and a Jewish star on the headdress of the bearded man. For many fifteenth-century Europeans, Jews and Muslim Turks were equally dangerous opponents of Christ's teachings.
Bosch achieves emotional intensity in this work through various means. His composition is shallow, tight and claustrophobic. He also provides his figures with an impressive array of facial expressions, from wide-eyed anger to cynical dismissiveness and determined aggression. In the midst of this hostility, Christ gazes directly at the viewer. His face is weary, but it also reveals the knowledge of his destiny as forgiver of human sin—including the sins of his torturers.

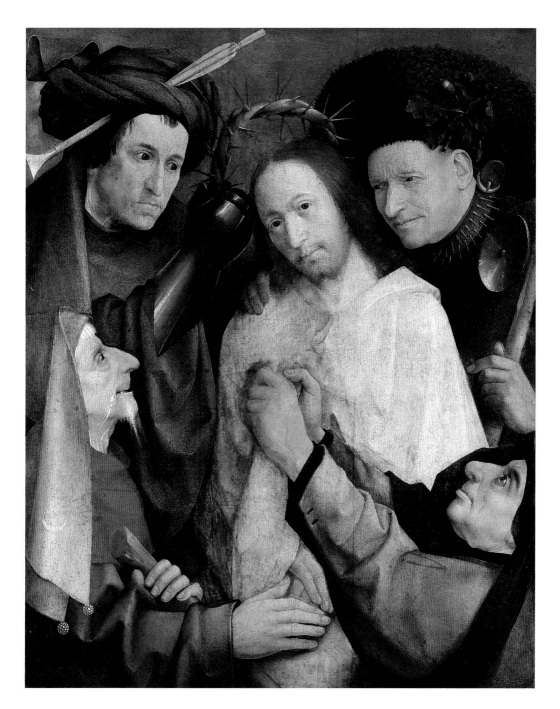

The Ascent of the Blessed, c.1505–1515

Oil on oak panel
88.8 × 39.9 cm
Museo di Palazzo Grimani, Venice

"For in the darkness there shines and is born an incomprehensible Light, which is the
Son of God, in Whom we behold eternal life."
(from Jan van Ruysbroeck's *The Adornment of the Spiritual Marriage*, c.1350)

This mystical panel is one of four surviving paintings in Venice that describe the "visions
of the hereafter." Today, Bosch experts believe these works were meant as side panels
flanking a larger painting, possible a scene of the Last Judgement. Two of the panels
illustrate humankind's descent into hell, while the other two show the ascent of the
blessed into heaven. In this image, naked individuals float upwards toward the "incom-
prehensible light" of God, their souls unburdened by the weight of sin. Angels escort
them on their journey, but the naked souls need no physical assistance.
Historian Walter Gibson and others have suggested that Bosch's tunnel of light may be
derived from fifteenth-century manuscript illuminations. For example, in *The Seven Ages
of the World* (c.1460), often attributed to the French illustrator Simon Marmion, heaven
is shown as a funnel that leads to an image of God on his throne. Such pictures may
have been known to Bosch, but he went well beyond them in his own work. Marmion's
funnels were two-dimensional and rather decorative in appearance, while Bosch's cre-
ation pierces the black sky and extends dramatically into the distance. He also chooses
to avoid figural representations of God, and instead illustrates heaven as a mystery—an
abstract, almost blinding light that only the eyes of the blessed can fully appreciate.
The heads of his souls and angels are turned upward, emphasising the spiritual ecstasy
of their ascent.
Medieval mystics, such as the Dutch author Jan van Ruysbroeck (c.1293–1391), used light
to describe the soul's oneness with God. But few painters were able to illustrate that
concept with such intensity as Bosch did in his *Ascent of the Blessed*.

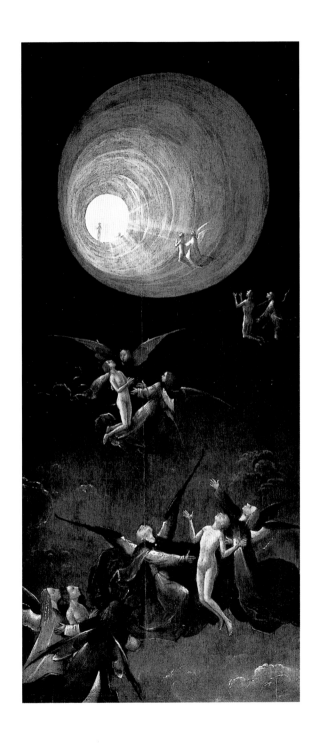

Christ Carrying the Cross, c.1495–1505

Oil on oak panel
142.8 × 104.3 cm
Monasterio de San Lorenzo de El Escorial, San Lorenzo de El Escorial

"And as they led (Jesus) away, they seized one Simon of Cyrene, who was coming
in from the country, and laid him on the cross, to carry it behind Jesus. And there
followed a multitude of the people, and of women who bewailed and lamented him."
(Luke 23: 26–27)

Hieronymus Bosch painted multiple scenes of Jesus carrying the Cross, a key
moment in Christ's Passion. This version, now at the Escorial outside of Madrid, is
a somewhat more intimate example, with the face of Jesus looking directly at the
viewer in solemn weariness. The "multitude" following Christ is a rather motley
crew, with unattractive, almost caricatured, faces that seem eager to witness the
upcoming execution. Lances, flags and horns in the back of the group suggest
an almost festive atmosphere. At the same time, a man in a red tunic with a whip
flagellates Christ as he walks, while other men have bucklers (small shields) on their
tunics, further indications of their cruel, warlike nature. The torturers have even tied
a nail-studded block to a cord that hangs from Jesus's belt, adding further pain to
his every step. In the front of the group, a "Roman" soldier sports a crescent moon
on his shoulder. Bosch uses this emblem of the Muslim Turks as a general sign of
anti-Christian sentiment.
Bosch also includes the figure of Simon of Cyrene, who walks behind Christ wearing
a white tunic. In the gospels, Simon is enlisted to help carry the Cross, and some
medieval painters show him as a benevolent figure aiding Jesus in his slow proces-
sion to Calvary Hill and the Crucifixion. Here, however, Simon's assistance appears
to be rather minimal. Christ's body is almost collapsing under the weight of the
Cross, while Simon's hands have no more than a casual grip. The Cyrenean appears
more interested in the conversation he is having with a bearded man, possibly a
Jewish Pharisee, than in Jesus's suffering.
Beyond this scene of anguish, Bosch crafts a particularly elegant landscape. The
Virgin Mary and Saint John the Evangelist are embracing on a small, winding path-
way, fully aware of the tragedy about to take place. In the background, Bosch's
Jerusalem—like much of the painting—uses imagery that would be familiar to his
viewers, a walled Netherlandish city with massive stone towers and soaring Gothic
churches.

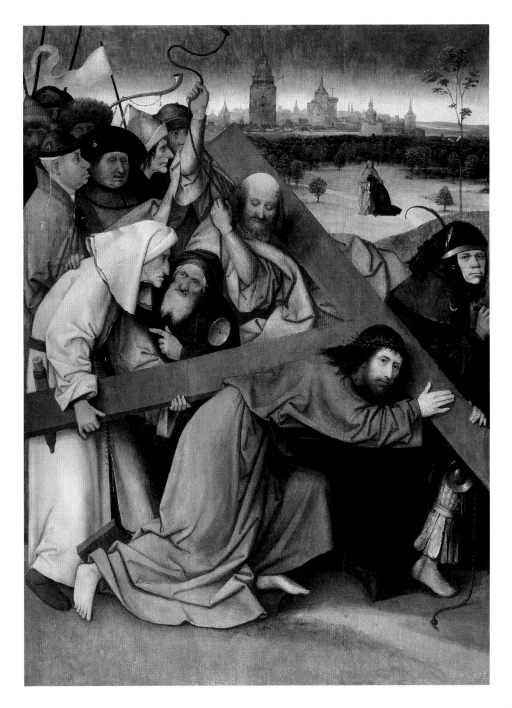

Christ Carrying the Cross, c.1490–1510

Oil on oak panel
59.7 × 32 cm
Kunsthistorisches Museum, Vienna

"One of the criminals who were hanged railed at him, saying, 'Are you not the
Christ? Save yourself and us!' But the other rebuked him, saying, 'Do you not fear
God, since you are under the same sentence of condemnation? And we indeed
justly; for we are receiving the due reward our deeds; but this man has done noth-
ing wrong.' And he said, 'Jesus, remember me when you come into your kingdom.'
And (Jesus) said to him, 'Truly, I say to you, today you will be with me in Paradise.'"
(Luke 23: 39–43)

This version of *Christ Carrying the Cross* is now displayed at the Kunsthistorisches
Museum in Vienna. It was painted around the same time as the Escorial version
(page 91), but it has a very different character. The setting has been broadened to
illustrate several moments of the Passion, including the story of two beggars who
were crucified along with Christ. The "unworthy" beggar at lower left is arguing
with the soldiers and officials, while the "worthy" beggar who showed sympathy
for Jesus in the gospels is confessing his sins. The monk to whom he confesses
is surely not part of the Biblical story, but he would have made the picture more
engaging and comprehensible to Bosch's late medieval viewers.
Once again, Bosch emphasises the suffering of Jesus through callous or militaristic
torturers, the nail-studded blocks under Christ's feet, and the lack of assistance
from Simon of Cyrene, shown here in a bluish cowl and red tunic. Other details
include the funnel hat on the man in the top left corner, a sign of ignorance; and the
shield with the oversized toad being carried in front of Jesus, a symbol of devious-
ness and immorality. The latter images were meant to remind Bosch's viewers of
their own sinful excesses, especially those committed during the wild, boisterous
carnival season.
Based on the findings of recent scholarship, this image was originally the left panel
of a larger triptych. At some point in the past, it was pared down, especially at
the top, where it would have had a rounded upper edge. Historians also note that
Bosch's procession moves from left to right, enticing the viewer's eye toward the
rest of the triptych.

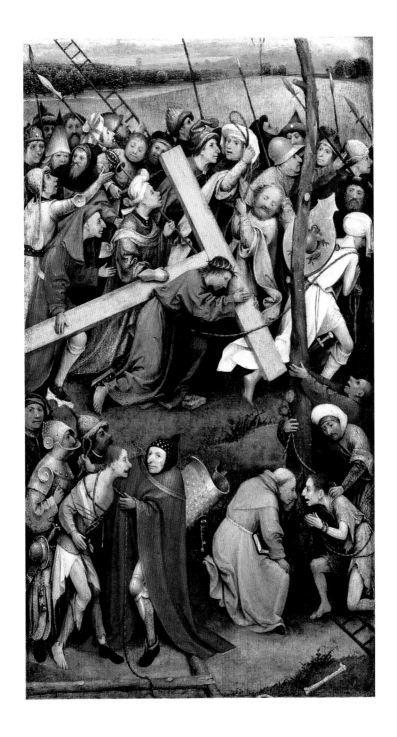

The Adoration of the Magi, c.1470–1480

Oil on oak panel
71.1 × 56.7 cm
The Metropolitan Museum of Art, New York

"The *Adoration of the Magi* was attributed to Hieronymus Bosch at the beginning of the twentieth century. Doubt was cast on this identification from the 1930s onwards, but the painting has once again been considered autograph since 2001." (from the Bosch Research and Conservation Project, *Hieronymus Bosch: painter and draughtsman: Catalogue raisonné*, 2016)

Because so little is known about the life of Hieronymus Bosch, including the dates of his paintings, historians have worked for decades to clarify which of the surviving works attributed to Bosch are actually in his hand. Dendrochronological dating of the wood in Bosch's panels and infrared images of his underdrawings have helped promote their efforts in recent years. During the 2010s, the Bosch Research and Conservation Project (BRCP) conducted a thorough investigation of Bosch-related paintings and drawings from around the world. This work, involving digital analyses and a gathering of evidence from earlier studies, resulted in a new catalogue raisonné for Bosch, published in 2016 to celebrate the 500th anniversary of his death. The dates listed for Bosch's art in this book reflect BCRP findings. Displayed today at the Metropolitan Museum of Art in New York, *The Adoration of the Magi* is now thought to be among Bosch's earliest works, dating from the 1470s when the artist was probably in his twenties. The figures are somewhat flat and inexpressive when compared with Bosch's later art. We see the Virgin Mary and the infant Jesus receiving offerings from the three Magi. Unusually, Bosch employs gold leaf, a typical feature of medieval painting, in much of this image—from the clothes and gifts of the Magi to the fabric on which Mary and Jesus sit. Each of the gifts is ornately detailed, much like the Gothic metalwork one would find in Netherlandish churches. Even the "stable" is shown as a palatial, though partly ruined, stone structure. All of this courtly elegance exists in stark contrast with the humbly-attired, aging Joseph in the green tunic. At this stage of his career, Bosch seems to perceive the Adoration as a stately affair—an elegant gathering of worldly and spiritual kings.

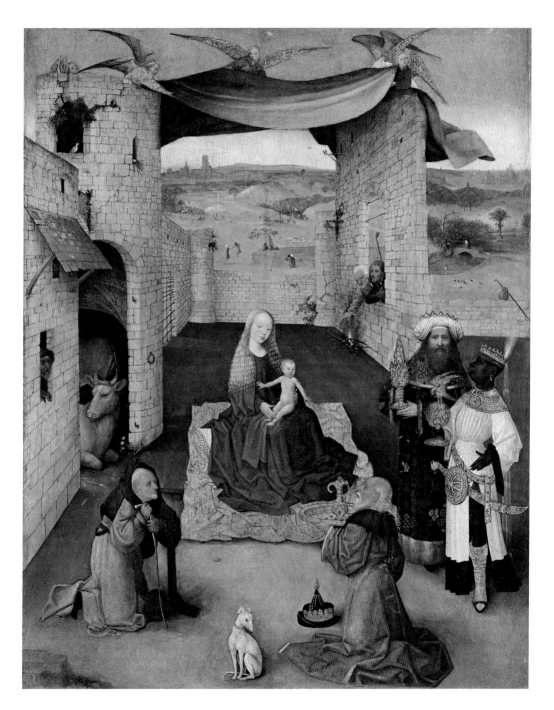

The Adoration of the Magi, c.1490–1500

Oil on oak panel
Left panel 138 × 29.2 cm, central panel 138 × 72 cm, right panel 138 × 33 cm
Museo Nacional del Prado, Madrid

This remarkable triptych is now displayed alongside *The Garden of Earthly Delights* in Madrid's Prado Museum. Although painted by the same artist, the two works differ strikingly in their tone and style. The surreal imagery in the *Delights* projects eeriness and intensity, while the *Adoration* appears serene and suggestive. Bosch sets the vignette of the three kings bringing gifts to Jesus against a rolling countryside that extends across all three panels of the triptych, giving the work an expansive sense of space. Jesus's stable is now a ramshackle farmhouse, bursting with hay and propped up by a bucking tree branch.

But while Jesus and the Three Magi may take centre stage, their presence in the triptych's overall landscape seems relatively small. Bosch's background includes a wealth of detail. Joseph is shown washing clothes in the ruined building on the left panel, and beyond him rises a vast panorama of tree-lined hills, farmhouses, windmills, lakes, and, in the far distance, a fancifully-rendered city of Jerusalem. All, however, is not peacefulness and harmony. Mounted armies approach each other in the central panel, while a man and woman are attacked by wild animals in the right wing. These images of war and danger prefigure the Crucifixion of Christ, along with the battles of the Apocalypse before Jesus's Second Coming.

In its recently-published catalogue raisonné of Bosch's art, the Bosch Conservation and Research Project provides information about the donors of *Adoration of the Magi*. Peeter Scheyfve, a wealthy Antwerp merchant, and his second wife, Agnes de Gramme, take a prominent place next to the Adoration scene. Both husband and wife kneel next to their patron saints, Saint Peter and Saint Agnes. Scheyfve prospered in the cloth weaving industry, and "he rose to become the dean and elder of the Antwerp weavers' corporation, and also served as a steward and city alderman." The catalogue notes that although donor and wife are dressed in pious black attire, their "sleeves are trimmed with ... expensive black damask. This is undoubtedly a reference to (Scheyfve's) profession as a cloth-dresser, in which he was evidently very successful."

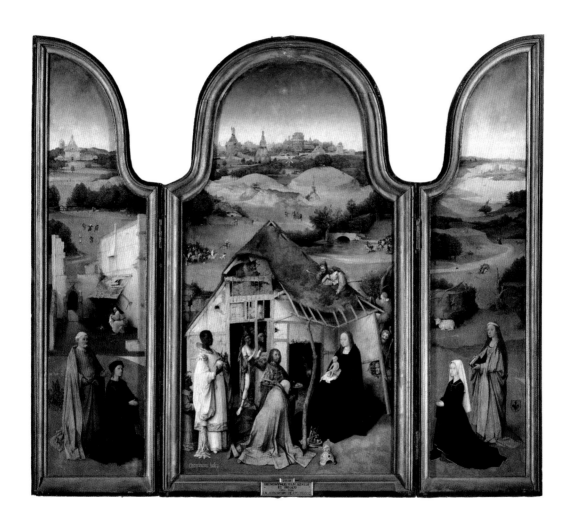

The Adoration of the Magi
(detail of lower central panel), c.1490–1500

Oil on oak panel
Left panel 138 × 29.2 cm, central panel 138 × 72 cm, right panel 138 × 33 cm
Museo Nacional del Prado, Madrid

In this detail from the *Adoration*, the Virgin Mary adopts a regal pose that we can find in other images of Mary from the fifteenth century. Both she and Christ have rather expressionless faces—they are objects of adoration rather than active protagonists. Bosch invests more of his painterly imagination in other characters. For example, in the Magi's sumptuous attire, we see finely detailed images from the Old Testament that foreshadow Christ's Adoration. The collar of the black-bearded Magus depicts the Queen of Sheba visiting King David, while the carving on the African Magus's ball-shaped incense holder shows another Old Testament king being greeted by visitors.

In recent decades, many Bosch historians have interpreted this scene not only as a meeting of cultures, but also as a gathering of good and evil. Peering out of the stable are men with ominous faces and expressions. Their leader is a half-naked, ivory-skinned individual. Bosch depicts him with a wide-eyed grin, a thorny "oriental" headdress, a wounded leg, and a helmet decorated with ape-like figures—details that suggest a wicked character. Historians Walter Gibson and Larry Silver and others argue that this figure is an Antichrist, a false Messiah that will precede the second coming of Jesus in the New Testament. His presence at the Adoration, along with that of his sinister compatriots, suggests that "evil" was lurking around Christ even in his earliest days. Other indications of evil may appear on the Magi themselves. For example, the black Magus and his attendant have embroidery at the bottom of their robes that shows half-bird, half-human monsters, as well as hideous creatures devouring other creatures. Such imagery is prominent in all of Bosch's depictions of hell and the Last Judgement.

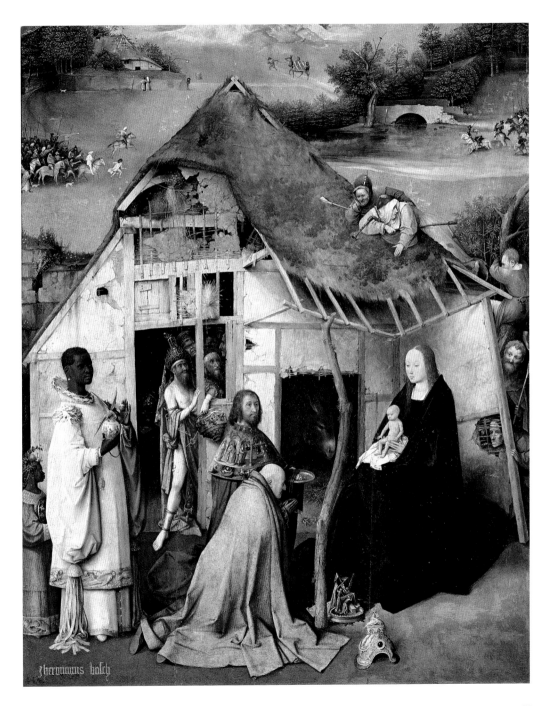

The Adoration of the Magi
(detail of upper central panel), c.1490–1500

Oil on oak panel
Left panel 138 × 29.2 cm, central panel 138 × 72 cm, right panel 138 × 33 cm
Museo Nacional del Prado, Madrid

"And in the spirit he carried me away to a great, high mountain, and showed me the holy city of Jerusalem coming down out of heaven from God, having the glory of God, its radiance like a most rare jewel, like jasper, clear as crystal. It had a great, high wall, with twelve gates, ..."
(Revelation 21: 10–12)

For late medieval and Renaissance Europeans, the city of Jerusalem was an idealised land derived from passages in the Bible and other writings. A few intrepid voyagers were able to make their way to the Holy land in Bosch's day, but for the most part the "orient" was a region of mystery.

For much of his artistic career, Bosch depicted Jerusalem as other Netherlandish artists had done: a walled city with the Gothic architecture his contemporaries would recognise. But over time, he would use his imagination to reinvent how the Holy City was portrayed in paint. In the central panel of the *Adoration of the Magi*, the artist invents a whimsical, almost futuristic Jerusalem. The basic shape of the walled city remains intact. But the Gothic spires have, for the most part, been replaced by massive, rounded gates and temples as well as oddly shaped domes and conical structures. The buildings have smooth, unadorned walls, and their forms may have been inspired by drawings of Byzantine and Islamic architecture from illuminated manuscripts. Bosch's city, however, is largely his own creation, and its architectural style seems to prefigure the Modernist and Expressionist designs of the early 1900s. As with his other cityscapes, Bosch employs aerial perspective to achieve a sense of depth. Foreground buildings are made larger and more detailed, while background structures are smaller and hazier. The artist also adds one entirely Dutch element to his city: a small windmill that stands in front of the outer gate.

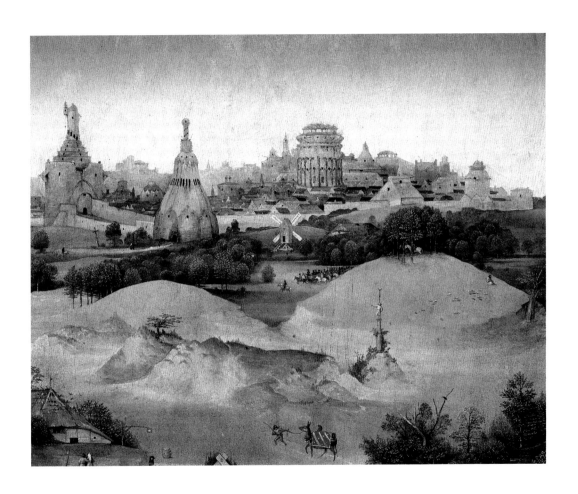

The Last Judgement, c.1500–1505

Oil on oak panel
Left panel 163 × 60 cm, central panel 163 × 127 cm, right panel 163 × 60 cm
Akademie der bildenden Kunst, Vienna

"Thus the angels, illumined by the light that created them, themselves became light and were called *day* by virtue of their participation in the immutable light and day which is the word of God, ... If an angel turns away from God, he becomes unclean, as are all those who are called unclean spirits. Deprived of their participation in the eternal light, they are no longer light in the Lord but rather darkness in themselves." (from St. Augustine's *The City of God*, Book 11, chapter 9, early 400s A.D.)

As with all of Bosch's great triptychs, *The Last Judgement* tells its story from left to right. The left panel begins with a powerfully visualised Creation story. An enthroned figure of God sits in heaven surrounded by angels, who in the Christian tradition were created before Adam and Eve. Below God we see a vivid battle between the God-fearing angels and the rebel angels who have sided with the devil. These satanic creatures have "become unclean," as St. Augustine describes them, and their glowing white bodies have metamorphosed into black toads and insect-like creatures. Bosch brilliantly illustrates them as a pestilence swarm raining down from their grey cloud and infesting the world. At the bottom of the panel, the story of Adam and Eve's own disobedience is shown in three separate vignettes: the joining of the first couple by God, the eating of the forbidden fruit, and the expulsion of Adam and Eve from the Garden of Eden by a sword-wielding angel.

As our eye moves toward the centre and right panels of the triptych, we take a giant leap forward in time—all the way to the Last Judgement. Bosch's version of this story differs markedly from those of other artists, including Rogier van der Weyden, who focused on the act of "judgement" itself—the weighing of souls by God. In Bosch's painting, the sinners have already been judged and are now suffering their punishment. Once again, hell is rendered as a scene of nighttime warfare, complete with monstrous objects of torture and composite human/animal devils. At the bottom of the right panel, the devil himself appears out of an archway lined with toads. He wears a green headdress in the style of an Ottoman turban, a symbol of heathen unbelief, and his lizard-like body is fuelled by a smouldering furnace in his chest. This fiery devil's light reflects the explosive flames in the city above. Above the smouldering Hades, a figure of Christ is enthroned in heaven and surrounded by disciples and angels. To the left of Jesus, tiny blessed souls are being escorted into heaven. Bosch makes these figures almost imperceptible, revealing a belief that true salvation is almost impossible for people in a sinful world.

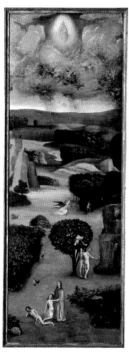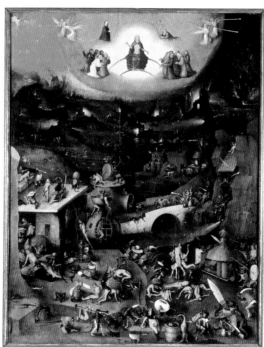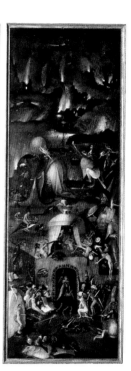

The Last Judgement
(detail of left panel), c.1500–1505

Oil on oak panel
Left panel 163 × 60 cm, central panel 163 × 127 cm, right panel 163 × 60 cm
Akademie der bildenden Kunst, Vienna

"And the woman said to the serpent, 'We may eat of the fruit of the trees of the garden; but God said, 'you shall not eat of the fruit of the tree which is in the midst of the garden, neither shall you touch it, lest you die.'' But the serpent said to the woman, 'you will not die. For God knows that when you eat of it your eyes will be opened, and you will be like God, knowing good and evil.' So when the woman saw that the tree was good for food, and that it was a delight to the eyes, and that the tree was to be desired to make one wise, she took of its fruit and ate; and she also gave some to her husband, and he ate. Then the eyes of both were opened, and they knew that they were naked; …"
(Genesis 3: 2 7)

In recent years, Larry Silver and other Bosch scholars have written about the lack of positive female characters in the artist's work. With the exception of Saint Wilgefortis (page 81) and a few other examples, Bosch's women tend to be stoic, expressionless representations of the Virgin Mary or despotic female devils. This misogyny, common in the late medieval world, is especially evident in Bosch's rendering of Adam and Eve's temptation from the *Last Judgement*. Medieval Europeans saw Eve as responsible for humankind's original sin and its expulsion from the Garden of Eden. Here, Bosch shows Eve holding out the forbidden fruit to her husband, who tries in vain to look away from her dangerous offering. Eve, however, is not the only devious female in the Garden. Bosch further emphasises feminine sinfulness by depicting the serpent itself as a half-woman, half-lizard creature. This composite monster uses its alluring upper body to fool the human couple, while hiding its deceptive, "reptilian" nature in the tree branches.

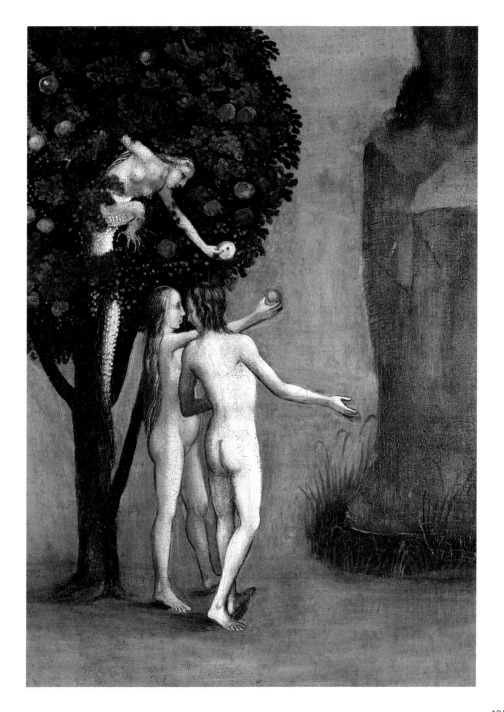

The Last Judgement
(detail of central panel), c.1500–1505

Oil on oak panel
Left panel 163 × 60 cm, central panel 163 × 127 cm, right panel 163 × 60 cm
Akademie der bildenden Kunst, Vienna

Bosch's hellscapes often have a disconcertingly modern look to them. In this detail from the central panel of *The Last Judgement*, the artist devises a vignette reminiscent of twentieth-century factories or prisons. The oversized blue grinder, into which sinners are being dismembered, resembles a machine from the industrial age, despite the fact that a human being is using foot power to operate its spiky treadmill-crank. To the left, a white stone building with a heavy slab roof is shown stripped of all ornamentation. With its tiny, barred window, it could almost be a Bauhaus-designed penitentiary from the 1930s. Such images must have been especially attractive to Salvador Dalí and the Surrealists, who were contemporaries of the Bauhaus architects and devotees of Bosch.

Although scenes such as this one can look almost chaotic at first, Bosch was quite careful in the way he depicted hellish punishment. The demons enact tortures that reflect the specific sins of the damned. At the bottom of this detail, we see two elderly women, one with a blue face and another with lizard-like feet. They are roasting and frying sinners who probably succumbed to gluttony during their lives. On top of the building, a naked woman symbolising lust and disobedience to God is being tortured by a serpent. Her punishment is meant to remind viewers of Eve's original sin—as well as the lustful serpent shown in the left panel of this triptych. Below her, a man who also represents lust is impaled on a long wooden stick or lance, his body and genitals at the mercy of another serpent-demon. Bosch includes other characters that ridicule the vanity of warrior knights and the heresy of people who worship Islam and other "false" religions. These include the helmeted and armoured fish-man at lower left, and the bearded man with the turban-like headdress and reptilian legs.

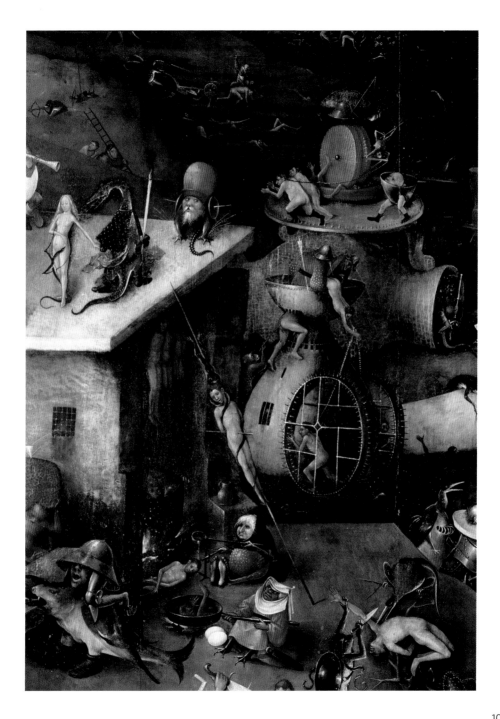

The Last Judgement (detail of right panel), c.1500–1505

Oil on oak panel
Left panel 163 × 60 cm, central panel 163 × 127 cm, right panel 163 × 60 cm
Akademie der bildenden Kunst, Vienna

"Therefore, as soon as all the peoples heard the sound of horn, pipe, lyre, trigon, harp, bagpipe, and every kind of music, all the peoples, nations, and languages fell down and worshipped the golden image which Nebuchadnezzar had set up." (Daniel 3: 7)

In the right panel of his *Last Judgement*, Bosch continues his depiction of hell from the central panel. Here we see the darkest depths of Hades, without any sign of the blue heaven from the other two panels. Inky-black demons conduct their evil business in front of Lucifer himself, whose reptilian foot can be seen at the right edge of this detail. The devils possess cat-like mouths and the bodies of monkeys, and they are accompanied by other monsters who either play musical instruments or whose bodies are composed of instruments. These demonic bagpipes and harps screech out a melody, while the monkey-demon and his female victim sing uncomfortably from an open music book. The vain pleasures of song and courtly life have been debased and transformed into acts of torment.

To the left of the musicians, a man has been shot in the chest with arrows and is being strangled by a serpent against a giant pink tombstone. Above him sits a bird-like creature that resembles a peacock, another image of courtly vanity; and below him creeps a lowly toad, an unclean, promiscuous creature. Still more toads appear on the archway of the devil's house nearby. This man, possibly the husband of the singing woman, has succumbed to the worldly temptations of frivolity and sensual pleasure. He and his wife are reflections of Adam and Eve. In Bosch's world-view, human beings may have begun life in the verdant Garden of Eden, but sin has doomed most of them to the muddy mire of Lucifer's domain.

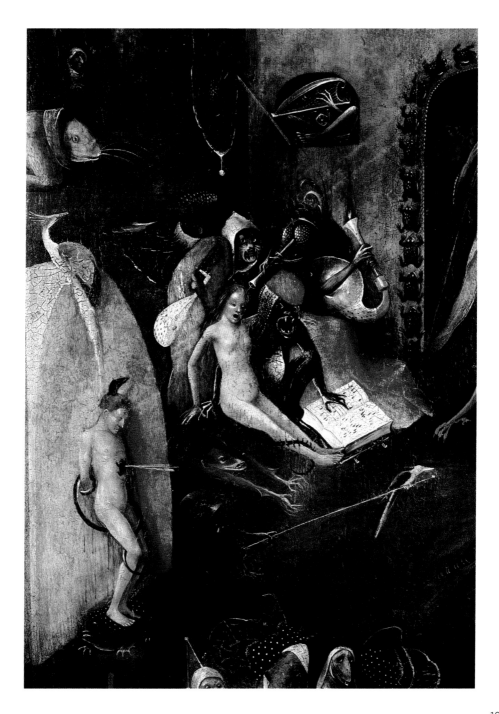

FURTHER READING

Belting, Hans, *Hieronymus Bosch, Garden of earthly delights*, Munich/ London/ New York 2002

Borchert, Till-Holger, *Bosch in Detail*, Antwerp/ Luidon/ New York 2016

Büttner, Nils, *Hieronymus Bosch: visions and nightmares,* London 2016

Cuttler, Charles D., *Hieronymus Bosch: Late Work*, London 2012

Dixon, Laurinda S., *Bosch,* London 2003

Gibson, Walter S., *Hieronymus Bosch,* London 1973

Hoogstede, Luuk/ Spronk, Ron/ Ilsink, Matthijs and others, *Hieronymus Bosch: painter and draughtsman: technical studies*, Brussels 2016

Ilsink, Matthijs/ Koldeweij, Jos/ Spronk, Ron, and others, *Hieronymus Bosch: painter and draughtsman: Catalogue raisonné*, Brussels 2016

Ilsink, Matthijs/ Koldeweij, Jos, *Hieronymus Bosch: Visions of Genius*, Brussels 2016

Koldeweij, Jos/ Vandenbroeck, Paul/ Vermet, Bernard, *Hieronymus Bosch: The Complete Paintings and Drawings*, New York/ London 2001

Koerner, Joseph Leo, *Bosch and Bruegel: From enemy painting to everyday life*, Princeton/ Washington, D.C. 2016

Maroto, Pilar Silva, ed., *Bosch: The 5th centenary exhibition.* London 2017

Rembert, Virginia, *Bosch, Hieronymus Bosch and the Lisbon Temptation: a view from the 3rd millennium*, New York 2004

Schwartz, Gary, *Jheronimus Bosch: the road to heaven and hell.* New York/ London 2016

Silver, Larry, *Hieronymus Bosch*, New York 2006

PHOTO CREDITS